PROFESSIONAL SECRETS OF
Wedding Photography

Second Edition

Douglas Allen Box

AMHERST MEDIA, INC. ■ BUFFALO, NY

Published by:
Amherst Media, Inc.
P.O. Box 586
Buffalo, N.Y. 14226
Fax: 716-874-4508
www.AmherstMedia.com

Publisher: Craig Alesse
Senior Editor/Production Manager: Michelle Perkins
Assistant Editor: Barbara A. Lynch-Johnt

ISBN: 1-58428-087-5
Library of Congress Control Number: 2002103406

Printed in Korea.
10 9 8 7 6 5 4 3 2 1

About the Author

Douglas Allen Box, M. Photog. Cr., CPP, has spent years inspiring photographers of all levels to go beyond the normal studio experience and create a more successful and creative business. Besides being an excellent photographer, he is a dynamic and entertaining speaker and has appeared in seminars and conventions across the U.S., Canada and Mexico. He was also chosen by Hasselblad University to teach at their International Wedding Institute in 1998, 1999 and 2000 and 2001. His fun and genuine style of teaching will help you learn to be a better photographer. His articles and images have graced the pages of most professional photographic publications. He is the author of *The Photographic Success Newsletter,* and has authored two successful books, *Professional Secrets for Photographing Children* and *Professional Secrets of Natural Light Portrait Photography,* both published by Amherst Media.

Contents

While speaking with a prospective client on the phone one day, I asked, "Are photographs important to you?" The woman's answer changed the way I thought about weddings. She replied, "Of course, that's why we are having a wedding!"

Chuckling, I commented, "I thought that's what the groom is for." Insightfully, she continued, "The groom is for the marriage, the reason for the wedding is to share it with friends and family and to record it for posterity!"

She was right. The marriage is about the love the bride and groom share with each other. You can have a marriage without planning a special wedding event. The wedding is an event designed to allow the couple to share this special day with the people they care about the most.

This means that our job as wedding photographers is multifaceted. We must:

Capture the Emotion. Show the personality of the wedding, the way the bride dreamed it would be.

Record the Details. Preserve the little things that make her wedding different from every other wedding in the world.

Show Her Beauty. This is one of the most important days in her life and she will never look more radiant. Our job is to put her on film in all her beauty.

Give Her Peace of Mind. Once she hires you, the bride and her family don't want to have to worry about photography. She trusts you. She trusts that you will create beautiful images and be professional.

In this book, you will learn the skills you need to accomplish all of these objectives, from taking top-notch wedding portraits, with beautiful lighting and elegant posing, to working with your clients and their guests to make being photographed by you a good experience for everyone involved.

The wedding allows the couple to share their special day with the people they care about most.

OUTDOOR LIGHTING

There is something special about natural light. It is somehow more expressive. Light can evoke

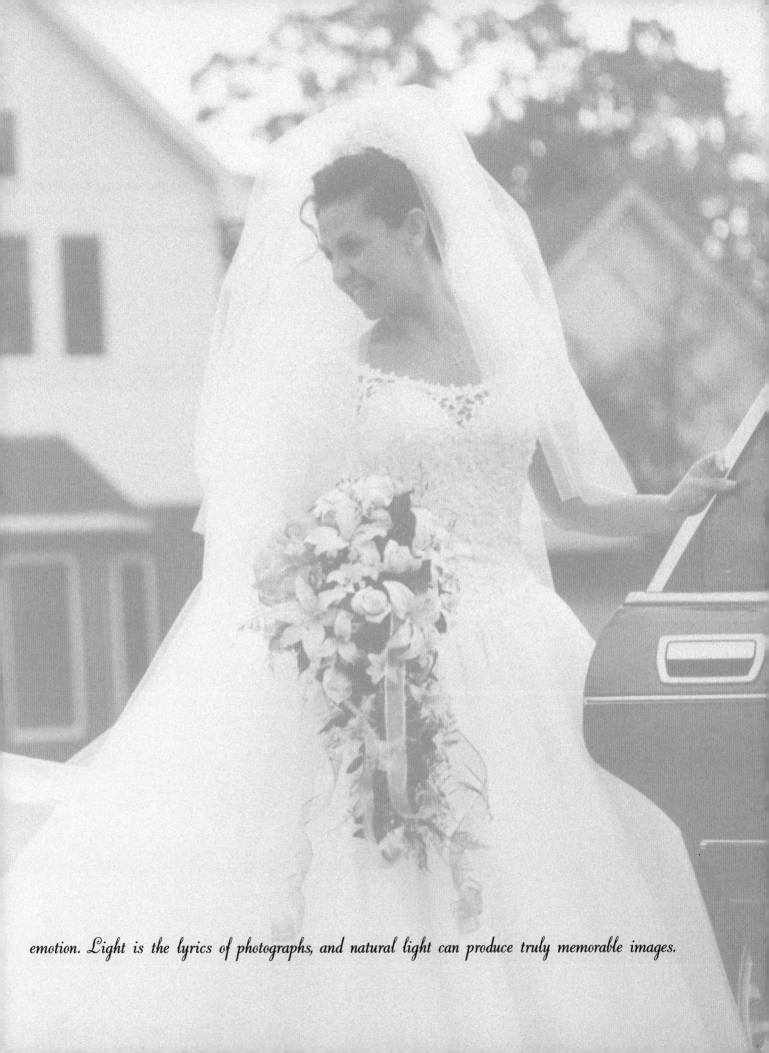

emotion. *Light is the lyrics of photographs, and natural light can produce truly memorable images.*

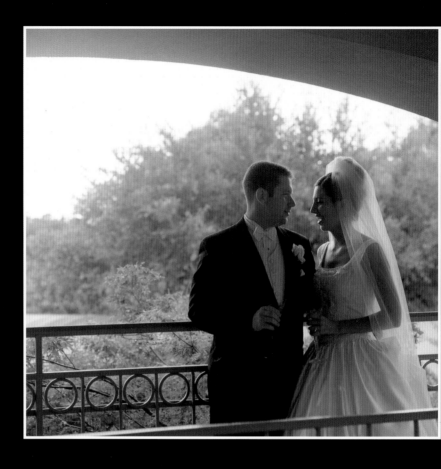

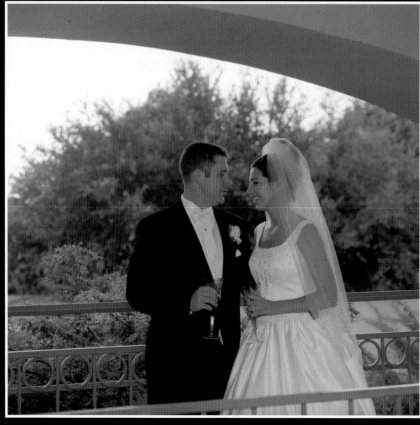

To me, film is cheaper than time at a wedding. On the wedding day, everything is in a state of perpetual motion, and that means that if a moment is not captured perfectly the instant it occurs, it may be gone forever. To improve the odds of getting this shot just right (and to provide myself with a couple of images to choose from for the album), I decided to take two pictures here. Creating multiple shots opens up your options when the time comes to assemble your images. Whether you choose a dramatic series of images with a lot of contrast, or something more subdued that shows a lot of detail, you'll be able to match up the "feel" of your shots with other wedding-day images when you take more than one photograph.

To get the first image, I pointed the meter toward the open sky area, then set the camera and made the exposure. This image was the original print from the lab. It could have been printed down for more of a silhouette look.

In the second image, I set the flash two stops under the meter reading. The camera flash was used as a fill light. When I say that I "set the flash two stops under the meter reading" I am adding flash as a fill light, not using it as a main light. The ambient light is still the main light source.

While every flash is different, with the Quantum Q-Flash, I can set the output of the flash exposure in ⅓-stop increments. For example, if the ambient reading is f5.6 at ¹⁄₆₀, and I matched the output of the flash to the ambient reading of f5.6, the flash would overpower the ambient light and create a flat quality in the lighting. By reducing the output of the light from the flash unit, the flash fills in the darker areas but is not overpowering.

In this example, I set the flash to give me f2.8 of light. On a manual flash system, I would have simply turned down the flash until the output was f2.8. With some other systems, I could have set the flash at the -2 setting, thereby achieving two stops under the recommended amount of light. This is a very important concept that will be discussed further in the following pages.

. . . if a moment is not captured perfectly the instant it occurs, it may be gone forever.

Simply Family

Here's a perfect example of using the flash as a fill light—but not over-filling and inadvertently making it a main light. When this outdoor image was taken, it was getting late . . . and growing a bit dark. In the top photograph, there was no flash used; there are dark shadows under the chin, nose and eyes of each of the family members. In the bottom image, my meter read $\frac{1}{60}$ at f5.6, and I set the flash to f4, which in this case was one stop under the ambient reading. This warmed the photo, eliminating the blue-green color cast. It also added light to the eye area, creating a much more flattering portrait. The background was lit with ambient light.

"To pose or not to pose" is a constant debate in photographic circles. I personally like both. If every image in a wedding album was posed, would the resulting photographs be a true representation of the wedding day? I think not! However, the bride and groom and their families want group portraits of the special people in attendance on their wedding day, and I believe that I would not satisfy my clients if I did not capture these folks in a nicely posed image. My wife Barbara and I work as a team to capture both her unposed, photojournalistic images and my own "orchestrated" ones. In this way, we can capture the spirit of the wedding as it unfolds, and ensure that we get all of the must-have images of people that are exceptionally important to the bride and groom. Chances are, without a posed image, we would not be able to capture all of these family members in a single frame. Of course, not all of my color images are unposed. I do a nice mix of posed, candid and photojournalistic images.

For more information on the photojournalistic approach to wedding photography, see Barbara's book, *Storytelling Wedding Photography*, published by Amherst Media.

It also added light to the eye area, creating a much more flattering portrait.

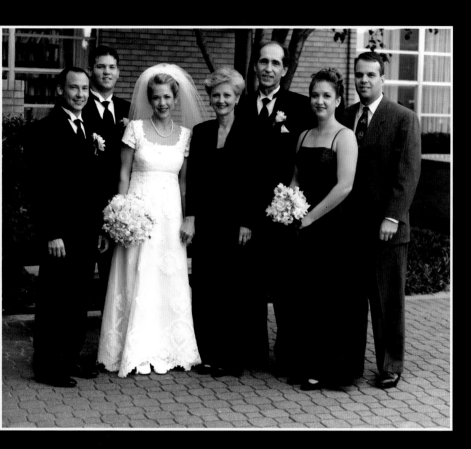

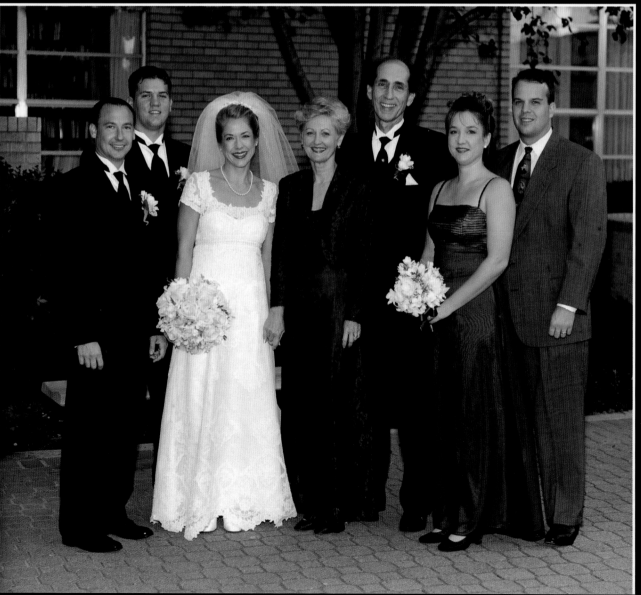

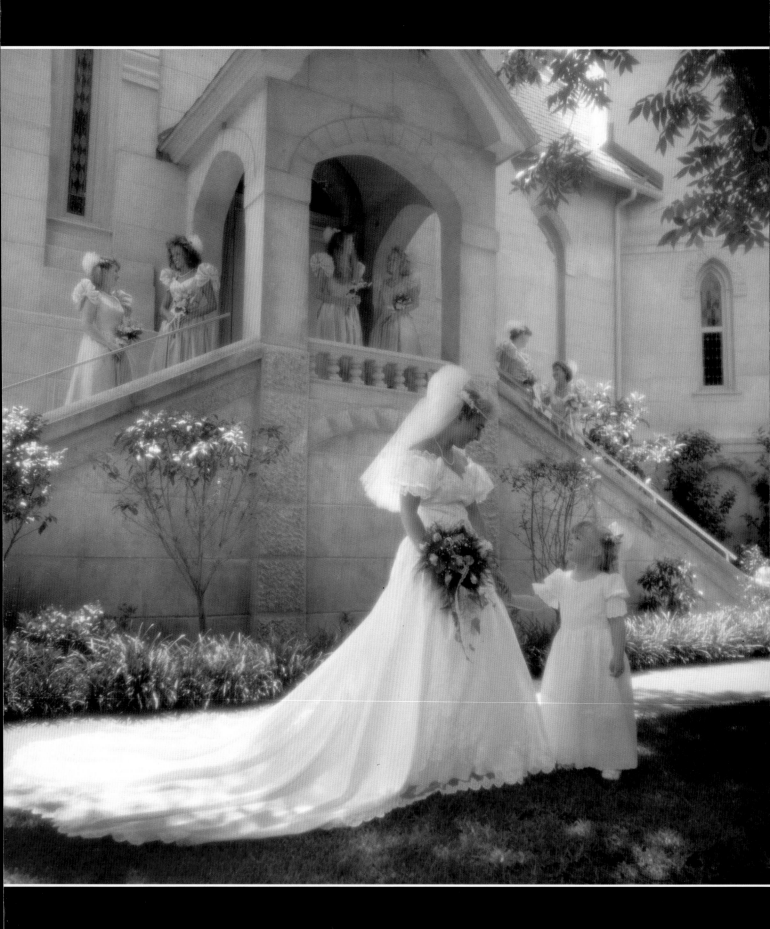

While this image *looks* spontaneous, the poses were actually orchestrated. I brought the bride and flower girl to the foreground and just let them be themselves; their visual prominence reflects their important roles in the wedding. The bridesmaids were asked to spread out along the stairs—a decision that ensures a more dynamic, more interesting composition than would result if they were placed in a straight line. The result is an image with beautiful design qualities that "carries" the story of the wedding.

The background—the front of the church—is the prop in this photograph. The diagonals of the stairs direct the viewer's eyes to the sanctuary and provide great separation for the girls, giving each her own space; they also frame the bride and flower girl in the foreground. It is important to include the wedding location in your images—after all, each location is chosen by a couple for a reason.

I used an 80mm lens on my Hasselblad to create this portrait, which was made when the sun was high in the sky. There is a bright strip of light behind the bride; if I were able to shoot later in the day (or on a cloudy day), this would not have been a problem. Of course, as a wedding photographer, you need to make the best image possible, no matter what the situation. So, to minimize the width of the light area, I lowered the camera and positioned the bride and flower girl in the shady area in the foreground. I did not use the flash because it would have made the foreground subjects too bright compared to the background. I wanted them to stand out against the light gray stone.

When working with children, I usually talk softly and playfully. The first rule of wedding photography is to remember that, while you have a job to do, you also have to be pleasant and polite. This is your clients' special day; don't ruin it by being pushy.

Hasselblad camera
80mm lens

A Private Moment

What could be more natural and sweet than the groom extending his hand to help up the bride? I was there to preserve this "private moment," and to capture the love the couple shares.

The arch that frames the couple plays a significant role in this composition. It gives the viewer the feeling that he or she has just walked into the scene, yet also separates the viewer from the subjects, providing the couple with a sense of privacy. The arch also adds depth to the image. Use your hands to cover the arch—"removing" it changes the whole image.

This courtyard is located just outside of the church where the ceremony took place. The bench was a natural part of the scene. If you ask a bride to sit on something like this, which might be rough or not perfectly clean, be sure to lift the back of her dress and have her sit on the petticoat. Then carefully place the gown down behind her to avoid getting it scuffed or dirty.

I used a 50mm lens on my Hasselblad to create the perspective needed to include the arch in this composition. To meter, I used the Sekonic L508 in the incident mode and the flat disk setting. The best way to determine your shutter speed and aperture in a situation like this is to walk up and meter the light at the subject. However, if you're trying not to spoil the mood, you can meter at a place that has the same light as on the subject. For this image, I stepped out from under the porch to the right and metered the light there. Because the qualities of the soft, late afternoon light were about the same value in the whole area, I was able to make a fairly accurate reading without disturbing the couple.

Hasselblad camera
50mm lens

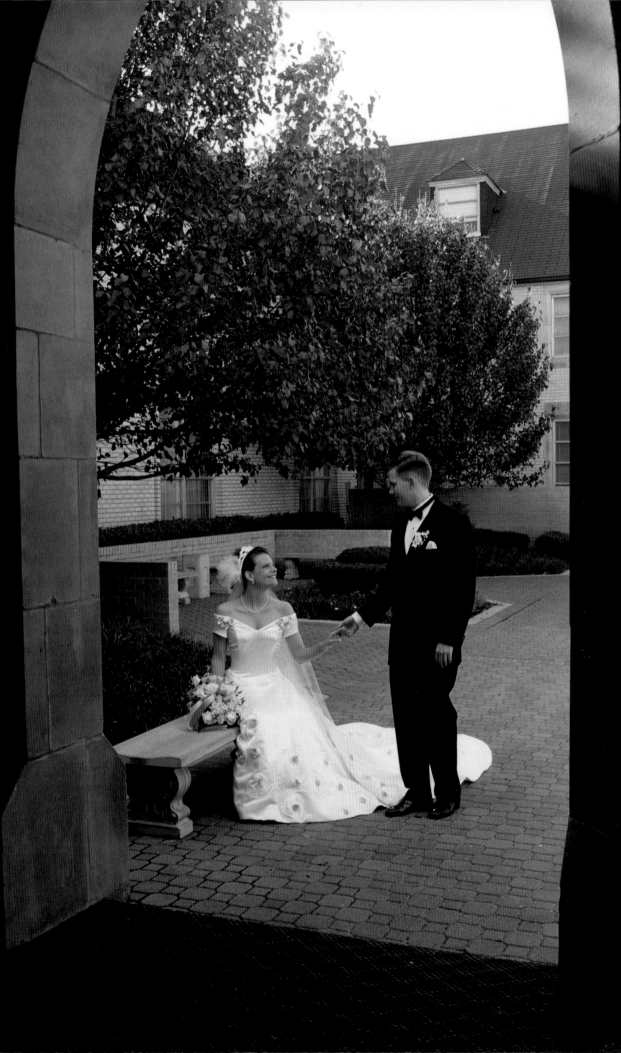

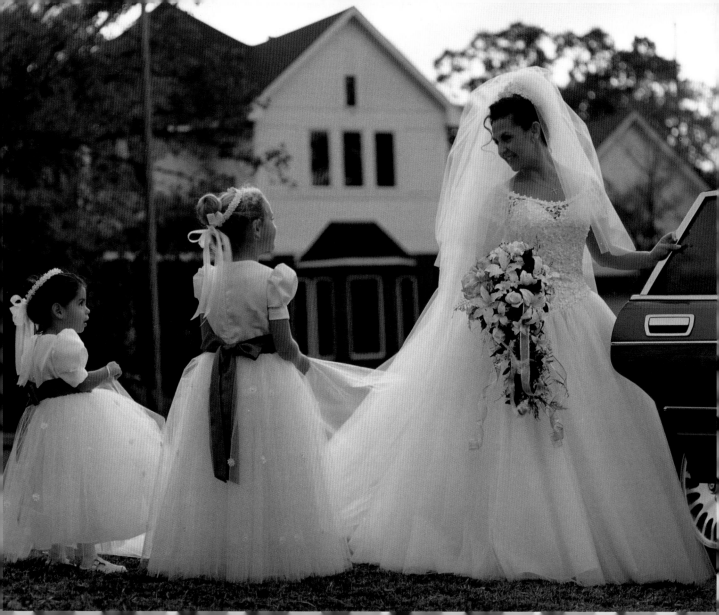

I have to admit that I set this up, because the wedding was scheduled to begin after dark. If we had taken this image when the ceremony actually took place, there would have been no natural light. For this reason, we planned to arrive at the bride's home and do some images with her, the flower girls and her family *before* the ceremony took place. I believe it's important to make an image feel as genuine as possible. I loosely placed the girls and talked them through a series of images as they held the dress and talked with the bride.

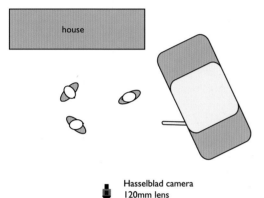

Hasselblad camera
120mm lens

The car and the dress are the props in this image. The bride had a long veil and two special young ladies to help her manage it. I needed to capture that and felt that the natural light made for a better image than an electronic flash would have. To add a personal touch to the photograph, I made her neighborhood the setting for this image.

I chose a 120mm lens to create some compression in the image and reduce the sky as much as possible, while still allowing me to work closely in a small area. I used a low camera angle for two reasons: to block out some of the houses and the road in the background, and also because of the small stature of the little girls. The low camera angle gives you the feeling of being on their level and seeing the world through their eyes.

I often talk to, rather than direct people. A storytelling conversation prompts people to act and react naturally, resulting in a more "candid" image. I've found that comments like "Can you help the bride get into the car?" and "See how pretty she looks?" can elicit movements, expressions and emotions that traditional posing would never evoke. If I had simply placed the girls and told them to stand and look at the bride, I would not have achieved a natural, believable image.

When viewing a scene, consider how various shapes, contrasts, lighting situations and backgrounds can be used to convey the feeling your clients are looking for in their images.

Triplets Are a Handful . . . of Fun!

I brought these children together in an area that would give me soft but directional light. "What does he have on that pillow?" I playfully asked. "Can you get the rings off?" Look at the natural action in the top left-hand image. Once I had the kids together, progressing to the portrait-style images was a natural step. The wonderment of children is one of my favorite parts of wedding photography. Children make a wedding special; their innocence and happiness add to the joy of the day.

It was just starting to sprinkle, so I had to work fast. A huge live oak tree provided the directional outdoor light. The canopy blocked the light from the top and protected us from the light rain. The church to the right blocked the light from that direction.

Notice how nicely the background is thrown completely out of focus in the group shots. The 250mm lens and wide open aperture makes this possible. I used Kodak PPF film ($\frac{1}{30}$ at f5.6) and a tripod to eliminate camera movement. A good rule of thumb for deciding when to use a tripod is to put a "1" over the focal length of the lens, and make that the minimum speed at which you can handhold the camera steadily. In this instance, I would have needed a $\frac{1}{250}$ second shutter speed (1 over 250 [250mm lens] = $\frac{1}{250}$) to reliably handhold the camera. The low-light situation dictated that I use a tripod.

A trick that I use to mesmerize children and almost always get a beautiful, natural expression comes from a friend of mine, Don Barnes from Denton, Texas. I take a quarter and push it firmly against my forehead. (It will stick there for a while—this seems to work best on oily skin.) Then I ask the children to blow it off. When they blow, I raise my eyebrows in a surprised look. The act of raising my eyebrows wrinkles my forehead and causes the quarter to fall. I catch it in my hand and start the whole process over. "Don't blow yet!" I tell them. "Is it still there?" I question. All this time, they tend to supply some truly memorable expressions. After they "blow it off," I almost always get a great smile. Usually I see the children trying to get a quarter to stick to their forehead for the rest of the day. It won't work for them, so they come back to me to see it work again. Thanks, Don!

The best piece of advice I can share with you about working with children is be ready! The cute little redhead in the lower images changed her mood in a split second, and I was there to capture this transformation as it happened.

The wonderment of children is one of my favorite parts of wedding photography.

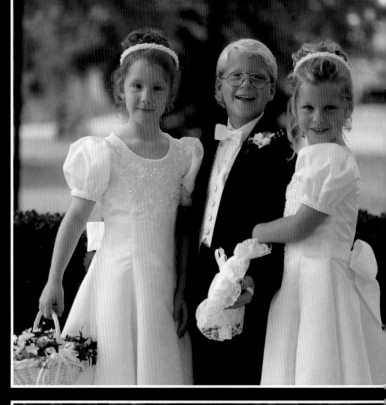

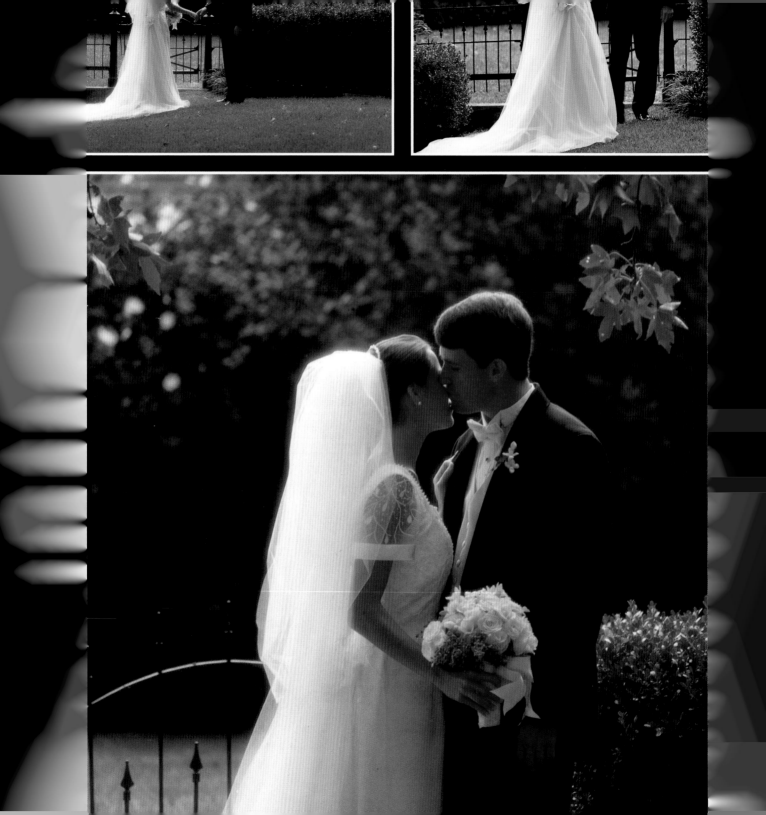

This series of images almost looks like frames from a movie: a spontaneous movement toward each other, reaching for a hand, and a gentle kiss.

The beautiful garden area in which these image were shot is located just outside of the sanctuary. There was a patch of open sky above and behind the couple that added the soft rim light to the images.

A 250mm lens (my favorite portrait lens) isolates the subjects from the background. I used a soft focus filter in two of the images to enhance their dreamlike quality.

I believe that the photographer's personality is at least 50 percent of what makes him or her great. How does the photographer work with the wedding party? Will he/she be polite and friendly with the guests? Can he/she read people and get the images the clients want without being pushy? Does the photographer work well with children? It is hard for the photographer to convey his or her personality to prospective clients, but it's very important to try to do just that. I believe that if you look closely, you can see the personality of the photographer in every image. If the subjects look natural and comfortable, it is probably because the photographer helped them feel relaxed.

The photographer's personality is at least 50 percent of what makes him or her great.

shade of tree

Hasselblad camera
250mm lens

Naturally Inquisitive

You can't get images like these by posing little boys. Children are naturally inquisitive, so use their curiosity. Let them be themselves, but give them gentle direction. "Those flowers smell like candy—can you smell the candy?" "What's in there?" or "Are you supposed to climb on that fence?" are questions that can bring out the beautiful personalities of children. But be ready; moments like these don't last long!

These images were made in a small garden next to the church. The beautiful gate made a wonderful prop and added another memory to the bride's album. Since this wedding was held at the bride's church, the garden held special meaning for her.

I used a 250mm lens in these images for two reasons: it limits the scope of the background (due to the small angle of view) and throws it out of focus (because of the limited depth of field). The long focal length also lets you work at a greater distance from the subjects, allowing the children to be more spontaneous. There is light from an open sky coming from the garden area at camera left, which supplied the directional quality of the light. The film used was Kodak PPF ISO 400.

Realism is an important part of storytelling wedding photography. Sometimes you have to encourage people because they are nervous or uncomfortable. However, one of the beautiful things about weddings is that everyone is in a good mood and having fun. My job is to record the story for the bride and groom (along with their family and friends) to enjoy for years to come.

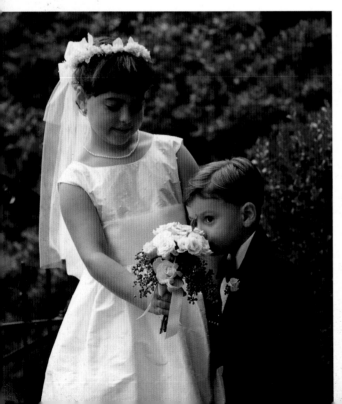

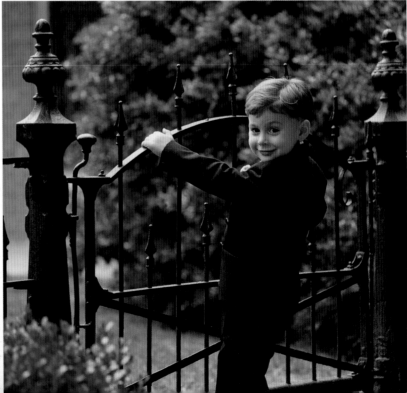

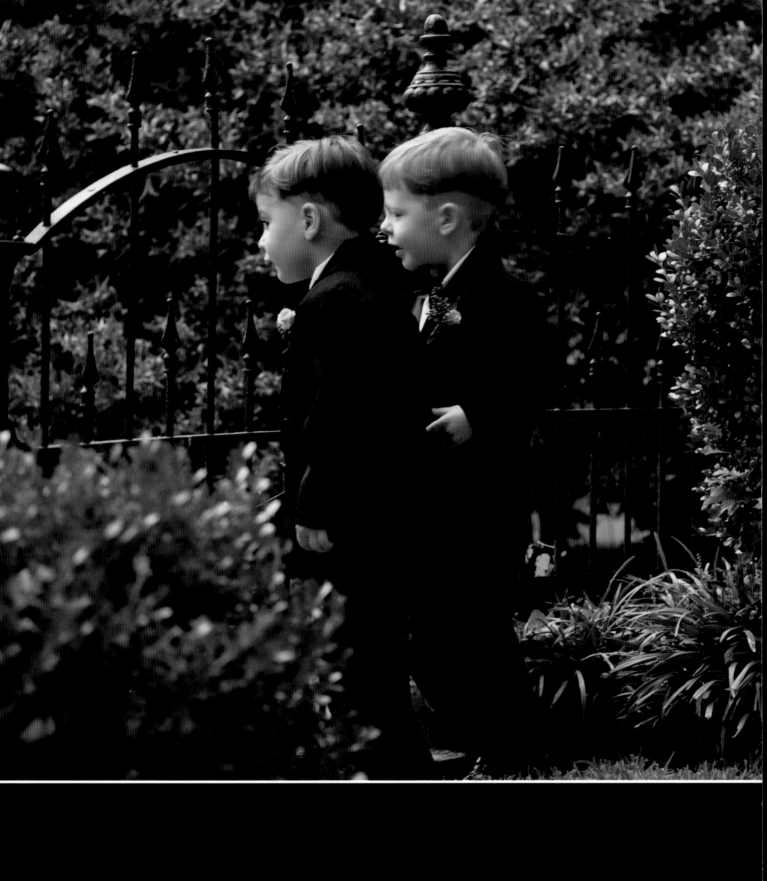

Grand Opening

While you'll rarely be fortunate enough to capture a scene like this as it naturally unfolds, you can gently encourage a recreation of a scene like this by talking to your younger subjects in an inquisitive way. Saying something like, "Do you want to go inside?" or "What are they doing in there?" can inspire behavior that produces this kind of priceless moment.

The door to the house is both the prop and the background. It is an important part of the illustrative quality of the image.

The photography couldn't be simpler—a good camera (Hasselblad), good film (Kodak) and a quick eye. The soft sun of late afternoon provided a beautiful quality of light.

One of the things I feel that a bride wants from her wedding photographer is peace of mind. Once she hires you, she doesn't want to have to worry about photography; that becomes exclusively your responsibility. Your experience, style, personality and your "eye" are what your clients want from you. Talk to the bride and groom before their wedding to discover how they want their wedding photographed, then capture priceless images that tell their story the way they dreamed it would be.

One of the things I feel that a bride wants from her wedding photographer is peace of mind.

Hasselblad camera
250mm lens

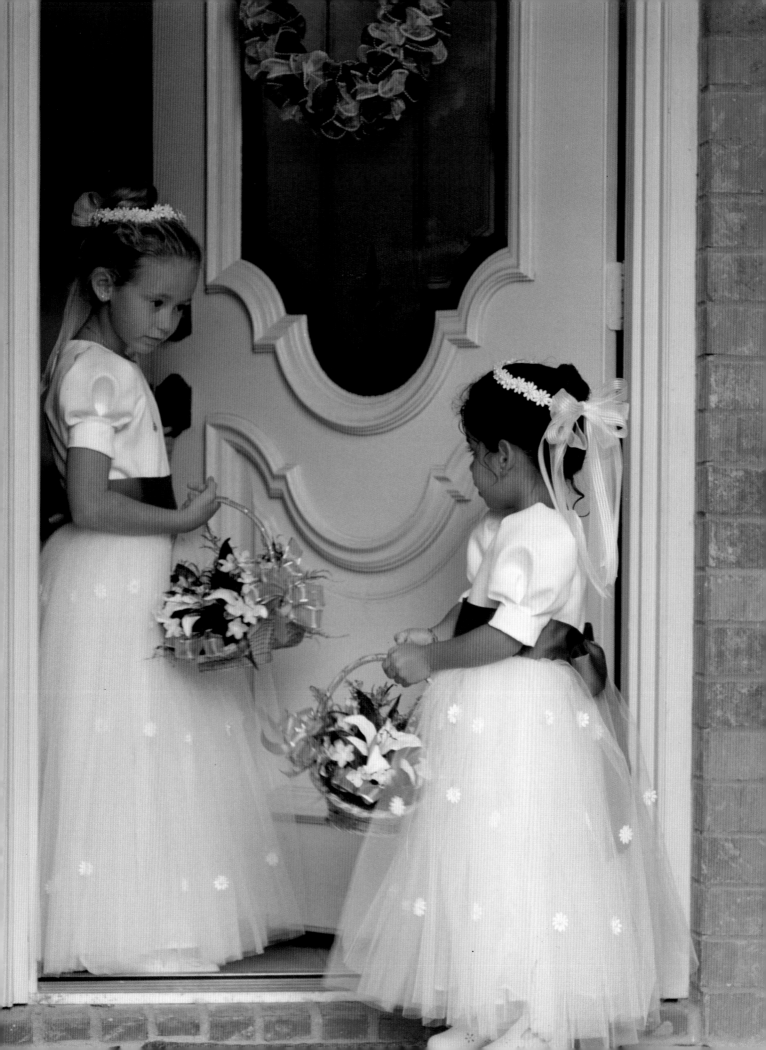

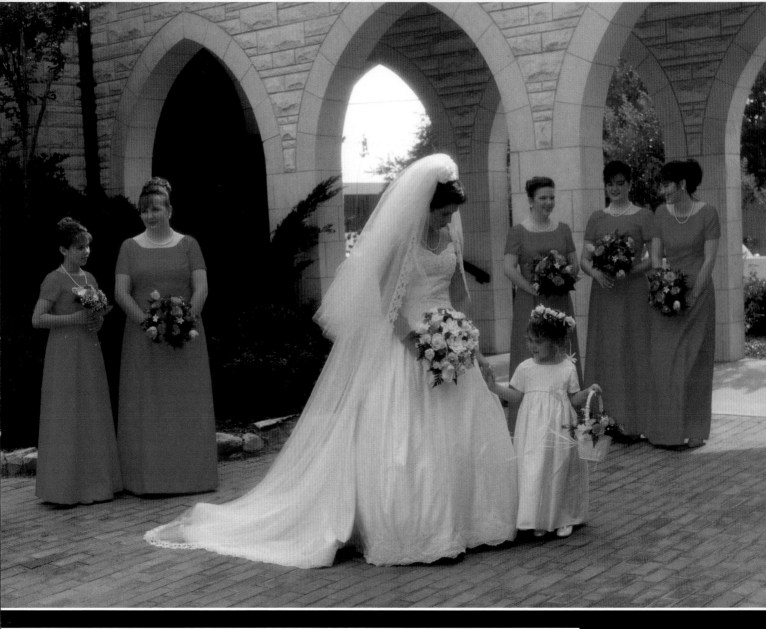

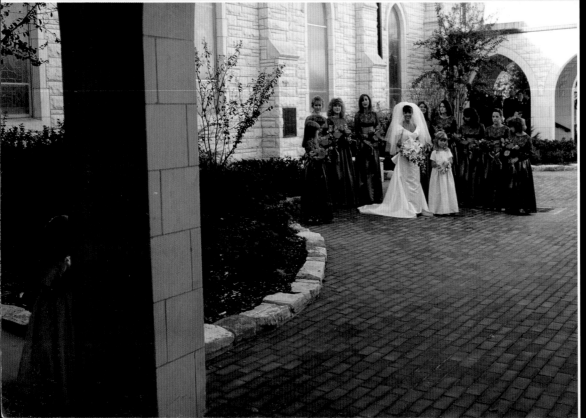

Occasionally Cooperative

Two versions of a similar image are presented here. The photograph at the top of the page was posed. When I pose groups, I try to create interest, depth and a feeling of spontaneity. I brought the bride and flower girl forward to create a sense of separation from the rest of the group.

In the bottom image, notice the little flower girl on the left. She did not want to cooperate for photographs, yet she always wanted to see what was going on. I noticed her hiding behind the post and told the bride and bridesmaids to stay put while I snuck around behind her to capture this priceless moment. This is a good example of how patience and ingenuity can result in an honest representation of real life. This image never fails to evoke a smile or a chuckle.

As you can see, both images were taken at the same church. This courtyard has archways on three sides. One of the sides always offers great light, making it a beautiful place to take photographs.

Both images were made with a 50mm lens, my Hasselblad camera and Kodak Pro 400 film in available light. This wide-angle lens has great depth of field, allowing almost everything in the image to be in focus. It also exaggerates depth and accentuates the foreground.

Both images are representative of a small chapter in the brides' wedding storybook. I realistically capture moments in a way that reflects the true nature and spirit of each bride's wedding day.

Hasselblad camera
50mm lens

Sweet Light

I call this light "sweet light." It's that last bit of light that you get just before the sun dips down below the horizon. It gives you nice directional light in a place where the lighting had been fairly flat before, producing beautiful, flattering images.

Where the bride and groom were positioned, the light had just been bouncing all around them. As soon as the sun dropped down below the horizon, it kicked up and gave me a little direction to the light. This warmed up the image and brought soft but directional light into the faces.

Here's a great exercise that will help you to find great light. First, find a patch of open sky and place your subjects in what instinctively seems like a good place, facing the position where your camera will be. Next, take a walk around the subjects. Take a second lap around them, but this time, have them turn with you as you walk around them so that you can see the effect that the changing direction of light has on their faces. When the light is just right, your clients will be in position for your shot, and you can refine the pose.

Another trick to finding great light outdoors is to look at the trunks of nearby trees. You should be able to see a light side and a dark side of each trunk. The tree will appear rounder in this light; when this light falls on your clients, it will create a flattering look. If the trunks look flat, you have not found good, directional light!

You can see the effect that the changing direction of light has on their faces.

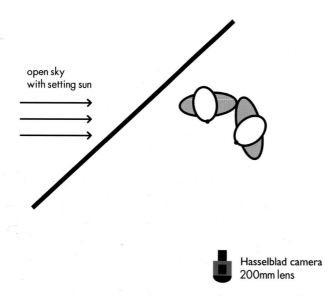

open sky
with setting sun

Hasselblad camera
200mm lens

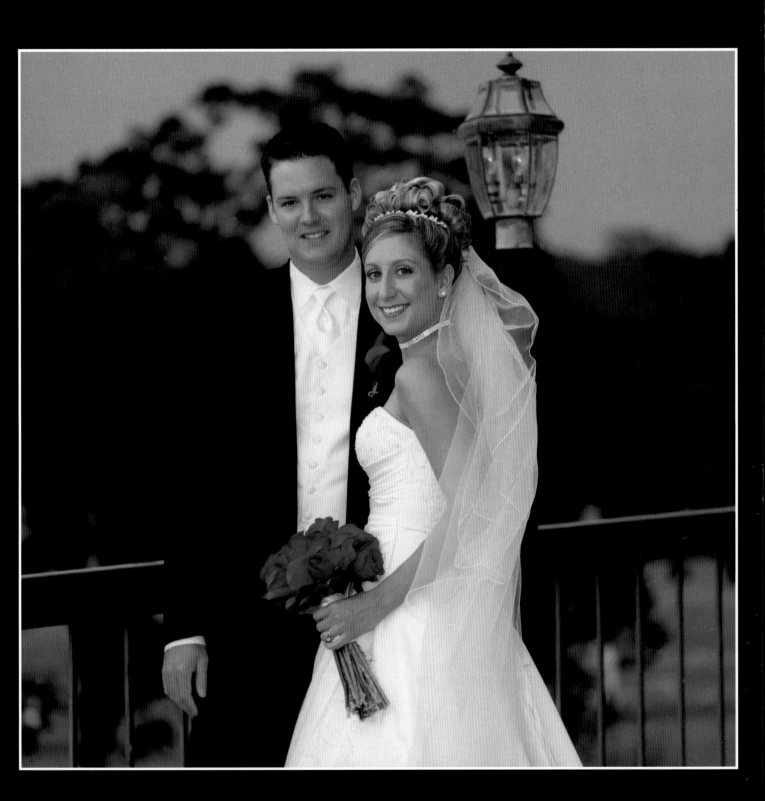

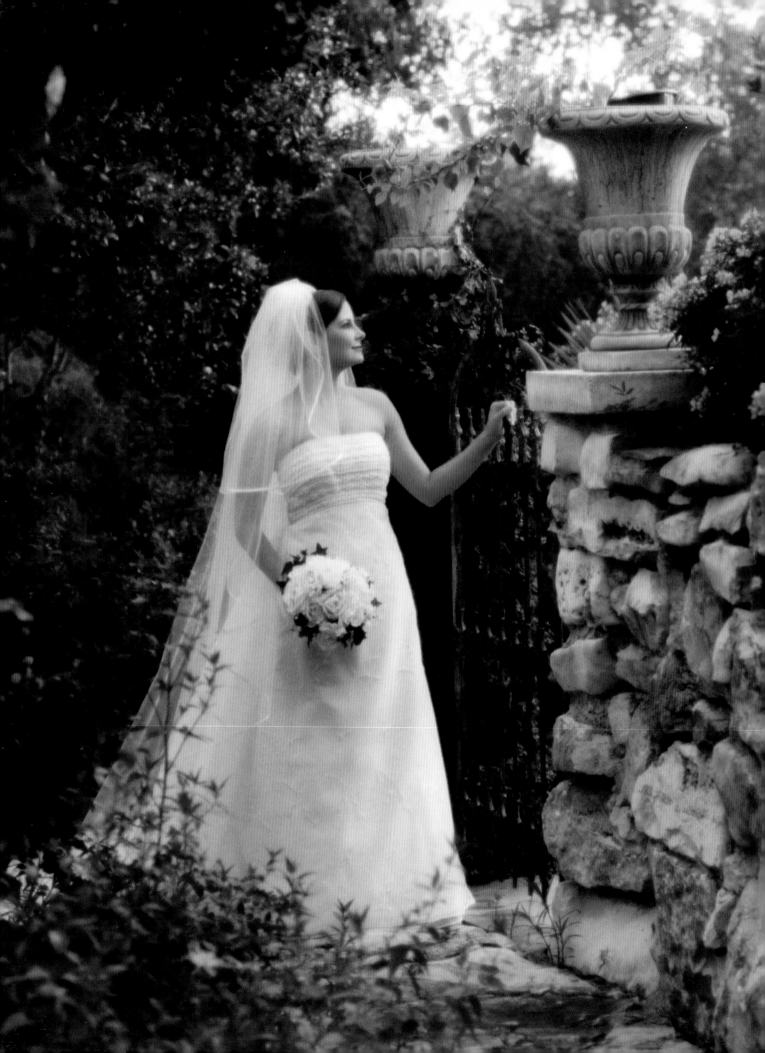

. . . the sun was just beginning

to set, and the sunlight was soft

yet directional.

Here is a perfect example of just how beautiful natural light can be. I had been working with this beautiful bride in different areas of this particular property, waiting for the light to become just right.

When I captured the image, the sun was just beginning to set, and the sunlight was soft yet directional. I turned the subject's body away from the light, and turned her face back toward it. I used a modified C pose, with her back arched slightly and and her head tilted back just a bit. Her left hand gently touched the gate and lent a sense of tenderness to the image. Her right arm hung gently by her side; I asked her to bend her elbow slightly to add space between her arm and waist to accent her slim figure.

This image was made with a 120mm lens on my Hasselblad camera. The exposure was $\frac{1}{15}$ at f5.6. I chose Kodak Portra 400NC film for its great tonality. No flash or reflector was used to create this image; all I needed was natural light and a tripod.

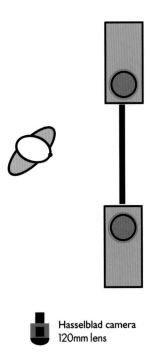

Hasselblad camera
120mm lens

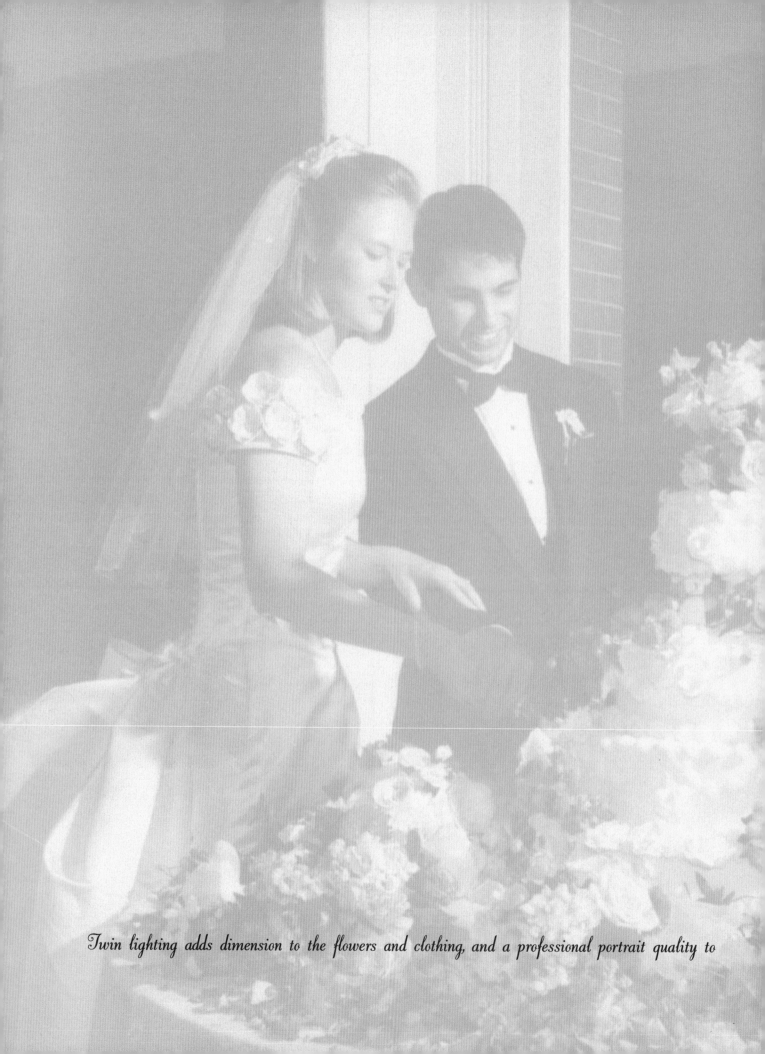

Twin lighting adds dimension to the flowers and clothing, and a professional portrait quality to

LIGHTING WITH FLASH

your images of people. Use it to put your own wedding photography on a more upscale level.

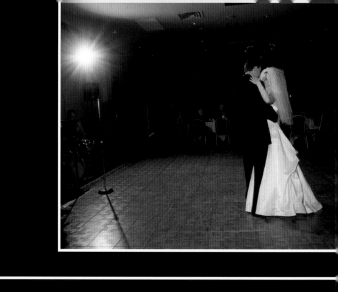
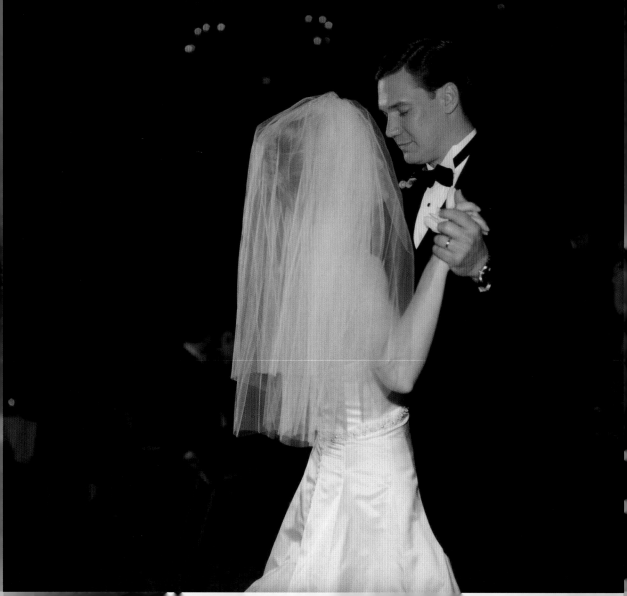

The setup for this image was pretty straightforward. I simply placed the flash by the DJ's speaker, pointing it toward the middle of the dance floor, and it gave me about f8. I used a 250mm lens on my Hasselblad 503CW, so I could stand out of the way and get a nice, relaxed shot of the action as it was unfolding. The second light, placed next to the bandstand, adds roundness and direction to the photograph. Look at the great light on the guy's face. I like to follow the couple around with my camera on a tripod, loosen its horizontal axis and wait until I get an expression that's really special. I may take eight, ten or even fifteen of these shots to make sure I get something special. Again, using the second light on the side provides texture in the image.

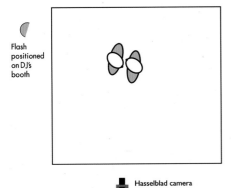

Flash positioned on DJ's booth

Hasselblad camera 250mm lens

The camera I'm using now is the Hasselblad 503CW, which can read the flash off the film. When light comes through the lens, it reflects off of the film and onto a little sensor that's in the camera. It reads only the light that comes through the lens, as opposed to the light that's bouncing off the subject.

Now, in many cases, this feature isn't totally necessary. For instance, if you're shooting a group shot, and everyone is on the same plane, the little automatic "eye" on the flash will work just fine. When your subjects are on multiple planes and you're shooting with a long lens, however, the flash may bounce off the ceiling, walls, etc., and *then* hit the flash sensor, providing an inaccurate reading. With the through-the-lens metering of the 503CW, I get a very accurate exposure, since only the light coming through the lens is accounted for.

The top photo was taken with a 50mm lens to show flash placement.

It is almost impossible

not to capture the

excitement of the day.

There is so much happiness apparent at a wedding that it is almost impossible not to capture the excitement of the day. Still, you have to watch and anticipate the action. This is where the on-camera flash, with its automatic exposure control, can mean the difference between a great image and no image. I use the Quantum Q-Flash on my Hasselblad camera. This flash is very accurate, lightweight and easy to use. I also keep the camera prefocused at about ten feet. That way, if I see that something is about to happen, I can move into position about ten feet away, raise the camera and make the exposure. Sometimes I even "shoot from the hip," without looking through the camera; other times I will hold the camera above my head and point it down toward the action. At f8, the 50mm wide-angle lens on the Hasselblad has a great depth of field, so if my focus is off just a little, the lens will still produce an acceptably sharp photograph.

Twin Lighting

Twin lighting (the use of two lights) can be used to add a second dimension to your wedding images. It adds texture to the clothing and flowers and a portrait quality to the photographs. The same results usually cannot be achieved with only the on-camera flash.

In the next several pages, you will learn several ways to use twin lighting in your wedding photographs. As you will see, sometimes the second light is used as a main light, with the on-camera flash used as a fill light. This is very similar to regular studio lighting.

Sometimes the second light is used as an accent or dimension light. In group photographs, this light skims the subjects, adding texture and dimension to your images. It should not overpower, as the light on the camera is the main light in these situations.

Another use for the second light is for special effects; for instance, you can place this light behind the veil to create a glowing effect. This type of application is used for impact. It separates your images from run-of-the-mill photographs.

The second light can also be used as a second main light on secondary subjects. In this case, the on-camera flash serves as a main light for the primary subject(s). I use this technique mainly to capture images of the bouquet and garter toss.

If you learn to use twin lighting techniques, you will see a marked improvement in your flash photography. It will also put your photography on a different, more upscale level.

With twin lighting, you will see a marked improvement in your flash photography.

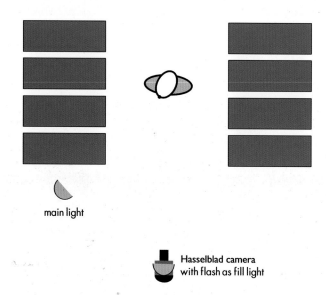

main light

Hasselblad camera
with flash as fill light

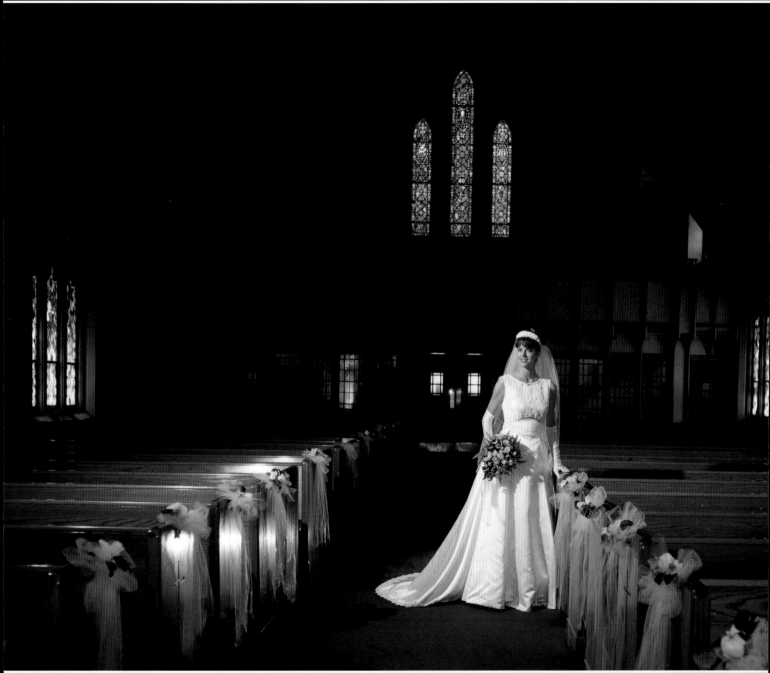

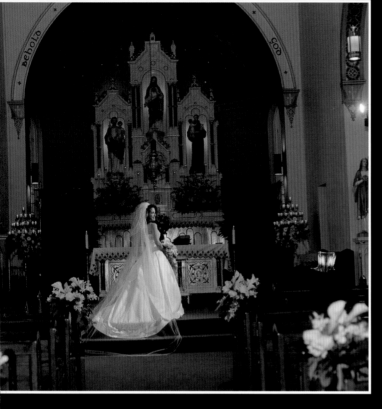
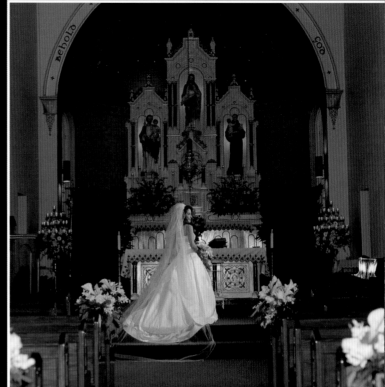
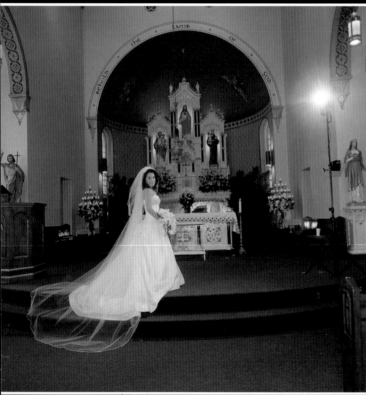
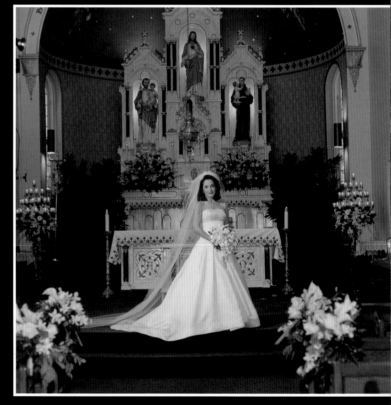

You can control the contrast between highlight and shadow areas with twin lighting. In this instance, the off-camera light is the main light (it can be seen just off to the right). I metered this light, achieved an f8 reading, and set my camera to f8. I determined my shutter speed selection by analyzing the level of brightness I wanted to achieve in the background. To achieve a darker background, I use a higher shutter speed, like $\frac{1}{60}$ or $\frac{1}{125}$. When I want a lighter background, I use a slower shutter speed like $\frac{1}{15}$ or $\frac{1}{8}$. In this series, the blue in the background was fairly bright, and I didn't want to overpower the image, so I set the shutter speed at $\frac{1}{30}$.

In the top-left image, the fill light is set one stop lower than the main light, at f5.6. In the second image, the shadows are deeper. I turned the flash on the camera (the fill light) down to f4 to get two stops less light than I have coming from the main light. In the second image, I would have cropped out the flowers on the left and right, but I wanted you to see the difference in the way they recorded here versus the way they appeared in the first image. You can also see a difference in shadows on the face, back and arms from the left-hand image to the one on the right. Again, I've given myself two images to choose from for placement in the bride's album.

In the third image, the bride turned and looked over her right shoulder. Had I used the same lighting setup, one side of her face would have been dark. I quickly turned the flash on the camera to f8, and left the camera set to f8 and $\frac{1}{30}$. While the image is a little flat, the second light, which acted almost as a kicker light here, was set at f8. It added a bit of light on the bride's left side and added more texture in the photograph.

In the fourth image, I wanted to brighten up the altar area. The light on the left-hand side was placed very high, at about ten feet, and pointed toward the bride, giving me f8. The camera was set at f8 and $\frac{1}{15}$, to open the background up a bit. The light on the camera is set one stop under. I'm getting a nice fill from the on-camera light, and I'm using the second light as a main light, which is set at one stop brighter. However, you can use it at one and a half stops or two stops brighter—that's totally up to you. Make several exposures, and decide which one you like best.

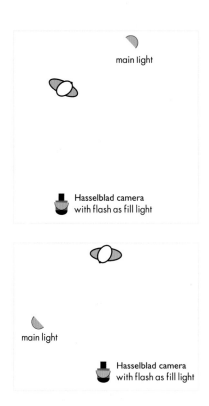

top: images 1–3
bottom: image 4

Classic Style

Sometimes an image needs a little finessing, as in the case of the image shown at the top of the opposite page. To create this image, I took a meter reading at the couple using the incident meter dome, then set the camera to ⅟₆₀ at f8 and made the exposure. The problem was, the resulting image didn't replicate the scene as it appeared to the couple. By reading the light falling on the subjects and creating proper exposure for them, the background—the sky—went much lighter.

Look at the image at the top of the facing page. This image appears the way the eye saw the scene. To create this image, I took a spotmeter reading of a dark area in the clouds that was about 18 percent gray (see the small circle on the grayscale image below). I then set the exposure as the reading dictated, at ⅟₂₅₀ at f5.6. Next, I added the flash at f5.6, which gave a perfect exposure on the bride and groom in the car. By carefully controlling the f-stop and shutter speed, I was able to create great exposure in the clouds and proper exposure on the bride and groom. Remember, flash is controlled mainly by the f-stop, whereas the background is controlled by a combination of the f-stop and the shutter speed.

To create this image then, I had to think about it as if I was creating two separate photographs: first, I metered for the ambient light and made the exposure for that, then I matched the ambient reading with the flash to get the proper exposure on the subject.

The problem was, the resulting image didn't replicate the scene as it appeared to the couple.

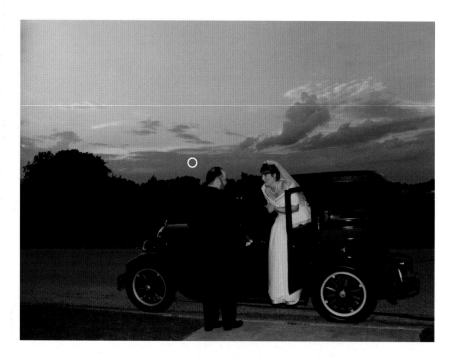

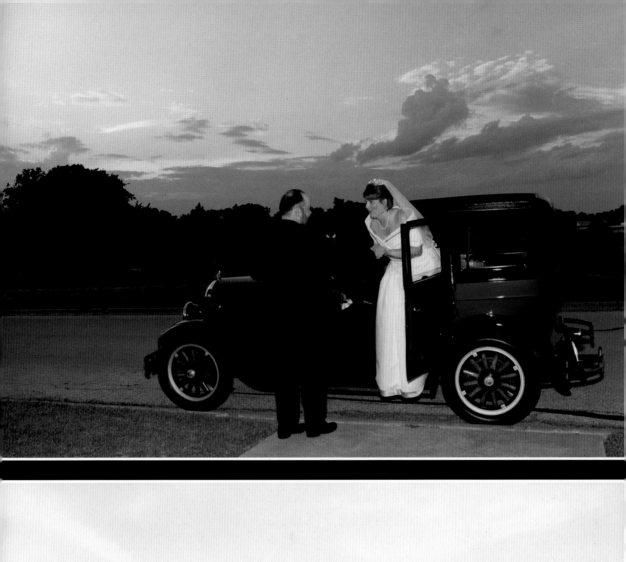

Sweet Details

Using twin lighting creates texture in the smooth surface of a wedding cake, while using only an on-camera light produces blown-out highlights and a very flat image.

In the top-left image, I brought the main light (off-camera flash) in toward the left at about 110 degrees, so its light would skim across the cake. I metered the main light, found that it read f8, and set the camera to f8. The on-camera light was used as a fill light. The shutter speed selection was not critical here. While it was $\frac{1}{30}$ in this case, I could've chosen a different speed too. If I had set the shutter speed to $\frac{1}{500}$, the background would have been almost dark; a slower shutter speed would've brightened up the background a bit. The background here was neither spectacular or awful, so I chose to slightly obscure it and set my aperture two stops under, to f4.

In the second image, the light was still on the left, but I placed it at about 90 degrees from the camera to accommodate some furniture.

In the last image, I placed the light on the right and dragged the shutter a bit more to bring out the Christmas lights on the tabletop. There is no "proper" side to place your light—just let the placement of the other tables, accessories, etc., dictate the position. You can almost taste this cake, and this will please not only the bride, but the baker as well. When you make the cake look better than any photograph the baker has ever seen made of her cakes before, you'll land some referrals, which will help to grow your business.

If you've never used twin lighting before, don't shoot everything with this technique at your next wedding. Instead, take advantage of a little downtime and set up your main light for a cake shot, then pull out your Polaroid back, set up the lights and run some test shots.

To begin, set and meter your main light. If it reads f8, set your camera and your on-camera light to f8. Next, bracket the images: set the on-camera light (the fill light) to f5.6 and take a shot. Next, take a shot at f4, then f2.8. Be sure to take notes on each combination so you'll know how each image was made. When you get your images back, study the results—you'll learn a lot from this exercise.

At your next wedding, take shots as you always have, but when the couple comes over to cut the cake, take one twin-lighting shot, then turn off that second light and continue as you normally do. *Do not* rely only on twin lighting here—you're bound to run into some problems, as this technique will still be new to you.

main light

Hasselblad camera
with flash as fill light

This is a traditional ¾-length pose of a beautiful bride. A good pose starts with the feet. Here, the bride's weight is placed on her back foot (the one farthest from the camera); her front foot is pointed toward the camera. The knee of her front leg is bent and pushed in slightly, which causes her back shoulder to drop a bit. Her shoulders are turned slightly away from the camera and her face is turned back toward it. This is the classic feminine pose; it gives a flattering S curve to the body.

The background is the bride's church, and I placed her off center for added impact.

There are several ways to use a second light. In this example, the second light is used as a main light. The on-camera flash is used as a fill light. I set the camera between f5.6 and f8. The flash on the camera was set at f5.6 on automatic. The second light, the main light, was set to f8. The shutter speed was set at $\frac{1}{15}$ second to pick up some of the ambient light. This is called "dragging the shutter." A faster shutter speed would have caused the background to go darker.

Unlike many photographers, we combine traditional and photojournalistic coverage of the wedding. The traditional style includes those wedding images that clients expect to see in their wedding albums: portraits of the bride and groom, attendants, and family members as well as the wedding "events" such as the cake-cutting, bouquet and garter toss, etc. The photojournalistic style includes unposed, spontaneous photographs captured during the wedding day—we use this style to capture the special details and candid moments that traditional photographers typically do not capture. With either approach, our goal is to create images that realistically depict the "feel" of the day.

There are several ways to use a second light. Here, it is used as a main light.

In the setup for these two images, the main light was placed off to the bride's right and set to f8. The on-camera light was set one stop less, at f5.6, and provided the fill light.

So where does the difference between these images stem from? I changed the camera position by backing up a bit to capture more of the background, as shown in the bottom image. I also chose to brighten the background by "dragging the shutter," which basically means matching the ambient light to the flash. Just as in the images on page 43, there are two exposures here. In the top photograph of the bride, the illumination from the on-camera light was controlled by the f-stop. I shot the image at the top of the page at $\frac{1}{125}$, which resulted in an image with a very dark background. To me, this screams *amateur*.

Because the background in the first image was too dark for my tastes, I selected a shutter speed that, in relation to the f-stop, would sculpt and control the ambient light. Since I wanted to brighten the background in the second image, I chose a slower shutter speed of $\frac{1}{15}$, which was three stops less than that used in the first image. This allowed the ambient light and the light from the stained glass to really open up and fill-in the image. Here, then, dragging the shutter produced a much better image.

Since I wanted to brighten the background in the second image, I chose a slower shutter speed.

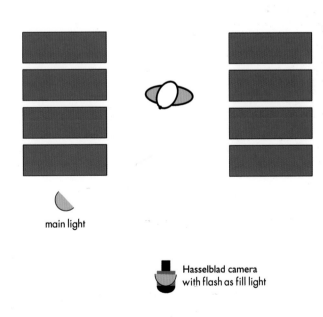

main light

Hasselblad camera
with flash as fill light

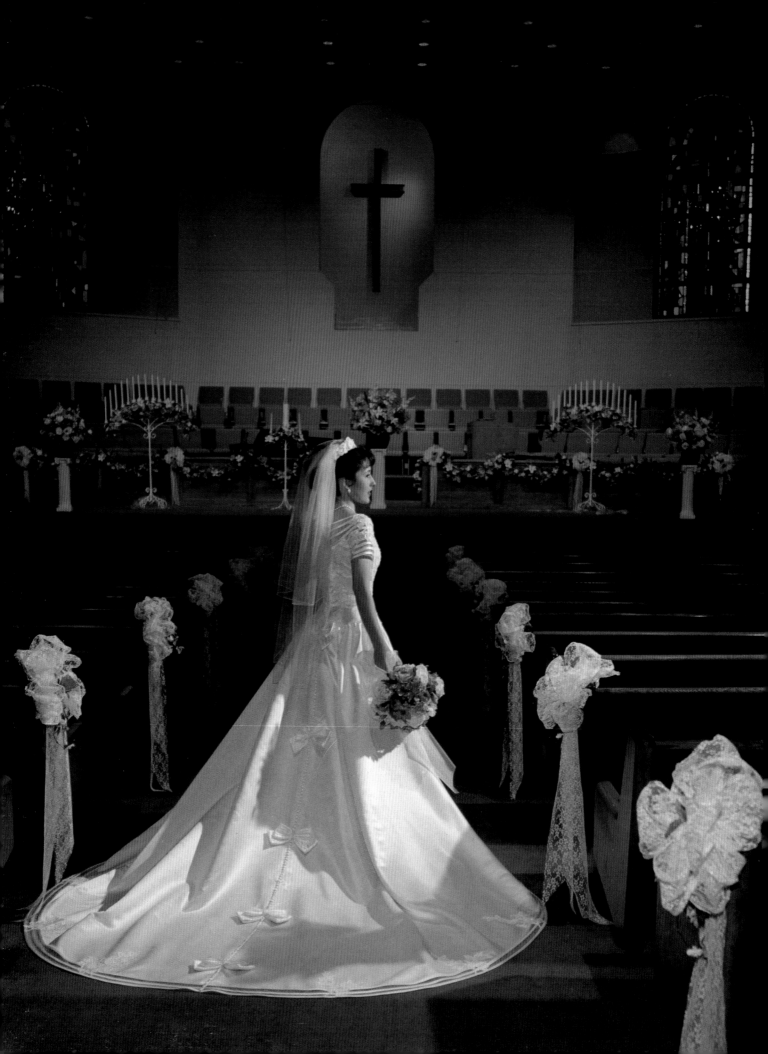

An Elegant Bride

This is another lovely pose for the bride. This image has several interesting aspects. First, I shot the image down the aisle instead of at the altar. This minimizes the altar area and emphasizes the bride. Second, this is a very classic pose. To create it, ask the bride to place her weight on her left foot and bring the right one forward, pointing toward the pews. Her shoulders should be turned at a 45-degree angle to the background. Position the bride's face in profile (where you see exactly half of her face). Point the flowers down, arm slightly bent, and tilt her chin upward to create separation from the shoulder.

There is a great deal of separation between the bride and the background. Because this church has almost no windows or natural light, the background, lit by incandescent light, provides a warm glow. The bows that adorn the pews lead your eyes to the bride. Some would argue that the bows are distracting; I disagree, and so I chose to include this decorative element, a detail that the bride chose for her special day.

Twin lighting plays a big role in making this image noteworthy. In this case, the second light is the main light. It is set one to two stops brighter than the fill light (the on-camera flash). You must decide how much contrast you prefer. I dragged the shutter to balance the subject and background. One way to think of dragging the shutter is to consider the subject and the background as two separate images that are combined. The flash is controlled by the f-stop. The shutter speed technically does not affect the subject or the flash, but determines how bright the background will be. In this instance, I chose a $1/15$ second shutter speed because I did not want the background to be too bright.

In wedding photography, there is a degree of compromise. You could use three lights rather than two, placing one light behind the bride to light her veil. Adding a forth, a kicker light positioned about fifteen feet back and to the left skimming off the back of the bride, might be nice. What about two lights illuminating the background? How about a spotlight on the cross? *Stop!* Remember, you only have a few minutes to do a few dozen images. This is not just a photo session; there is a wedding going on here! Your job is to do the best you can in a limited amount of time, and twin lighting really fits the bill. It adds another dimension to your photography, and takes it to a higher level. If I am without twin lighting at a wedding, I feel I am not doing everything I can for the bride.

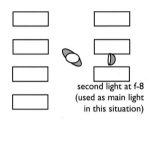

second light at f-8
(used as main light
in this situation)

Quantum Hasselblad
Q-Flash camera
set on 120mm lens
automatic set at f-8
f-5.6

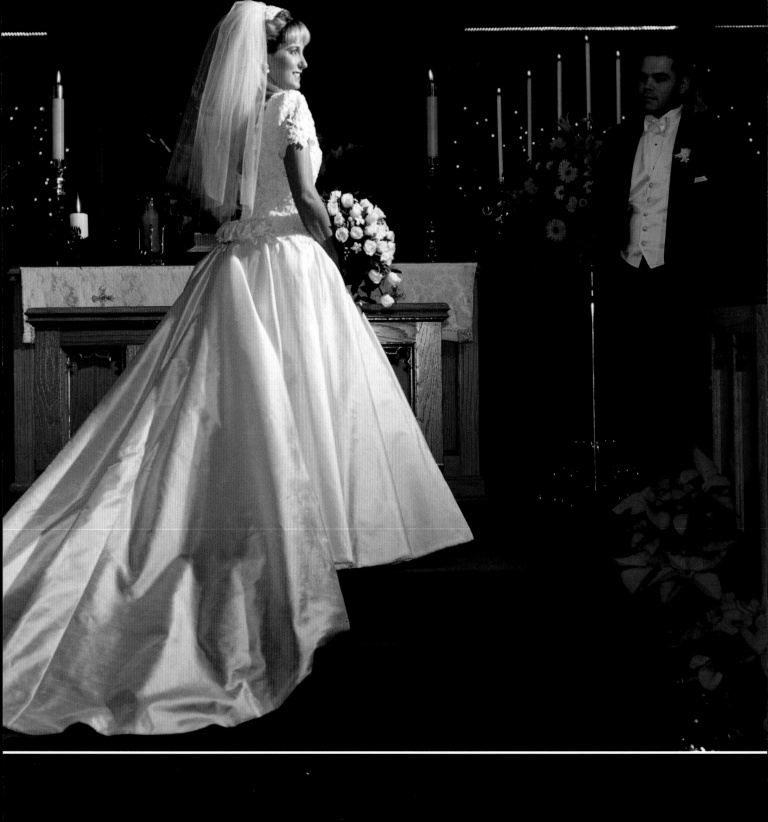

In Token and In Pledge

I didn't intend for this image to turn out the way it appears here. As I was preparing to do the "back profile" of the bride, I told the groom to relax for a moment. He moved off to the right, which, as it turns out, was not quite out of the scene. I decided to capture the moment as it happened rather than the way I had planned it. I knew I could get him in the image, but that the main light would not illuminate him sufficiently. The on-camera flash (fill light) would provide some light. However, he would appear darker than the foreground where his bride stood. While this was not what I had originally envisioned, it worked in a different yet equally pleasing way. In fact, what I like most about this image is that the newlyweds appear in the same shot and the lighting defines the bride as the primary subject and the groom as secondary in the image.

The background is the altar at the church. It was an evening ceremony, so I used a ⅟₃₀-second shutter speed to keep the background somewhat dark. If I had used a slower shutter speed, the interior wall behind the altar would have recorded lighter and seemed out of key for a wedding at this time of day.

With twin lighting, you can utilize your lights just as you would in the studio: the second light is the main light, while the on-camera flash is the fill light. Here, I set the fill light on automatic at f4, two stops below the main light, to produce a more dramatic image. One of the best things about the system that I use is that I can quickly change the contrast of the scene by changing the output of the on-camera flash. This can be very useful since, at weddings, you typically don't have a lot of extra time to work with. My wedding photography experiences have led me to the conclusion that time is far more precious than film. Instead of taking the time to test the exact exposure combination you want for each and every image with Polaroid film or precise metering, bracket your exposures to achieve a variety of contrast levels. Start with the main light and the fill light set at the same output (my main light is set on manual—the fill light on the camera is set on automatic). Then make a series of photographs, progressively increasing the differential between the output of the fill and main lights. On consecutive photographs, I change the output of the fill light by setting the f-stop one stop lower. The greater the difference between the two lights, the broader the resulting range of brightness in the image.

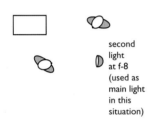

second light at f-8 (used as main light in this situation)

Quantum Q-Flash set on automatic f-4

Hasselblad camera 150mm lens set at f-8

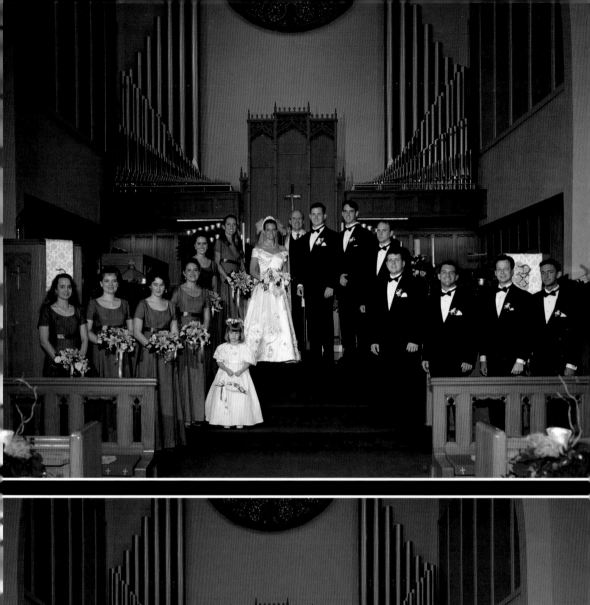
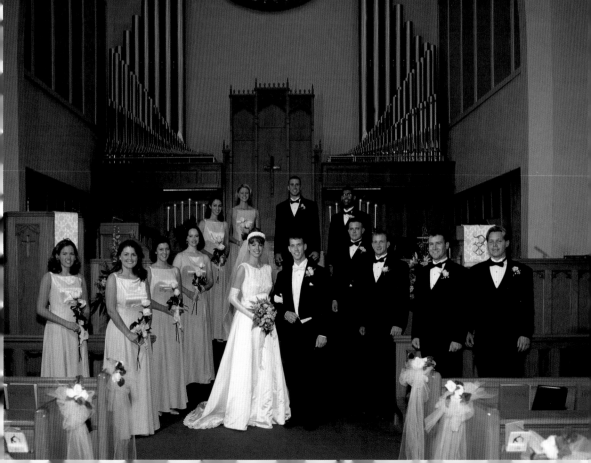

There are many ways to pose a wedding group, but as the photographer, you get to choose the composition that works best. In the top image, I placed the bride and groom at the top of the steps, with their bridesmaids and groomsmen lined up diagonally on either side of them. In the lower image, I positioned the newlyweds at the bottom of the steps. Both of these images feature the bridesmaids on the bride's right, and the groomsmen on the groom's left. This is the way the brides had their wedding parties stand during their respective wedding ceremonies, so that's the way I photographed them. Which image is the most effective? I like the bottom image; it makes the bride and groom stand out more.

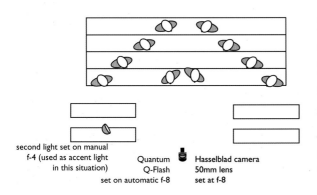

second light set on manual f-4 (used as accent light in this situation)

Quantum Q-Flash set on automatic f-8

Hasselblad camera 50mm lens set at f-8

To re-create the basic pose used in these images, have the wedding party turn slightly toward the center, and ask each subject to place their weight on his/her back foot (in this instance, the right foot for the guys and left foot for the ladies). Have the groomsmen drop their hands by their sides, ensuring a uniform look.

For this twin lighting setup, the second light is an accent light and the on-camera flash is the main light. The second light is set at a lower power setting than the main light, causing it to lightly skim across the group. (When first using twin lighting for photographing groups, many photographers set the power level of the second light too high. Start with this light at two stops less than the main light.) The second light should be raised as high as the light stand will go (mine is eleven feet tall), and placed approximately six feet to the left and six feet in front of the camera. I use the plain reflector, with a diffuser, on both strobes.

As a wedding photographer, you must work quickly and read your subjects. Always keep their minds off being in front of the camera, as most people are uncomfortable with having their photograph taken. Talk to the group and joke with them while getting them to follow your directives. Coming across as *nice* while keeping things moving is a talent you need to develop to become a great wedding photographer.

The Day That Lasts a Lifetime

While leaving the church for the reception, I quickly stopped this couple for about two minutes to make these images, and brought them together in the right place in relationship to the light. I suggested they hold each other, and that's all it took. They just naturally posed themselves, and I captured a moment that embodied the beauty of their wedding day.

The arch and the light are strikingly dramatic. Some locations virtually ensure a perfect image.

It was dark outside, so the shutter speed wasn't critical—except for the lamps outside the arch. To include those lights, I chose a setting of $\frac{1}{30}$ second so they would register, yet not overpower the image. The second light in this image was the main light. It was placed behind the outside wall to shine light on the subjects' faces. I used a reflector to keep the light off the wall behind them, as well as to give direction to the light. For the image on the right, I turned the on-camera flash off. I prefer this image, as the darkness outside the arch and the light inside it direct the eye to the subjects.

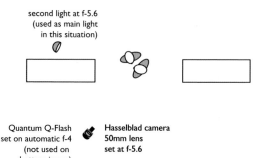

second light at f-5.6
(used as main light
in this situation)

Quantum Q-Flash
set on automatic f-4
(not used on
bottom image)

Hasselblad camera
50mm lens
set at f-5.6

Being the photographer hired to capture all of the special moments and all of the details that the bride has planned can be difficult. The bride trusts that you will perfectly capture the most important day of her entire life. You must produce images that validate her decision to choose your services over all the other photographers in your area.

To provide your client with the type of photography she's always dreamed of, you must first know what her needs and desires are. Most brides want to look beautiful, and enjoy their magical day—they do not want to worry whether or not you are capturing all of the details and special moments that make her wedding uniquely special. Try to get a detailed account of the type of images the bride-to-be is looking for before the big day, then make it your priority to preserve her special day just as she dreamed you would!

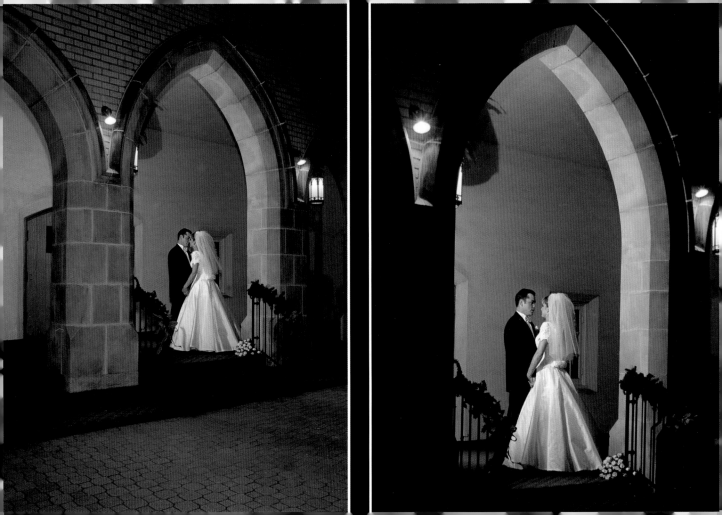

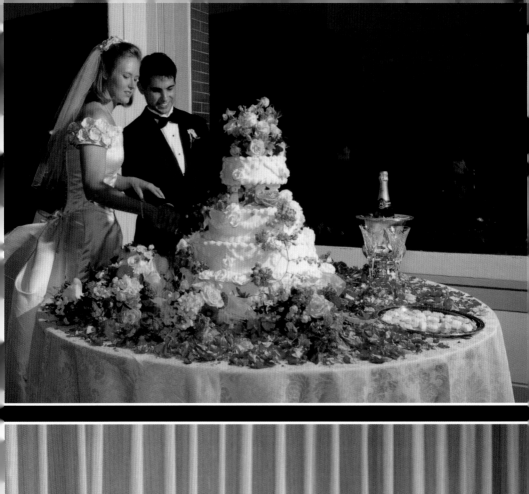

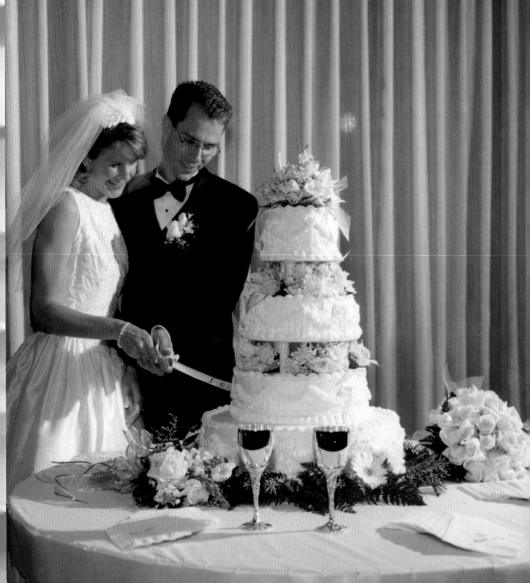

Cake-Cutting

second
light at f-8
(used as
main light
in this
situation)

Quantum Hasselblad
Q-Flash camera
set on 80mm lens
automatic set at f-8
f-5.6

I basically let couples cut the cake the way they want to, but I am sneaky about getting them in just the right spot without them knowing it. I like to place the groom on the far side of the bride to prevent his arm from "cutting" across her dress. Once I get the couple into a good position, I leave them alone and let them cut.

Naturally, the main prop is the cake. Record the details of the particular cake the bride has selected as best you can, making it look in the photograph as good as it does in real life—or better!

You typically don't have much choice on the background for shots of the cake—its placement is generally determined by the bride or the caterer. Still, you must watch for distractions. Sometimes moving the camera a few inches can make a big difference in the image. In the upper image, I had to place the flash carefully so that its light did not reflect in the windows behind the couple.

In this twin lighting situation, the second light has two functions. It is the main light for the bride and groom, and an accent light for the cake. Placing the second light to the right and in front of the cake allows the light to skim over it without becoming overpowering. If you want to start doing twin lighting at weddings, this is a perfect series of images to begin with, since you will usually have time to set up while other activities are going on. I recommend you set up the lights and camera, use a Polaroid back for your camera (if available), and test the setup before the actual cake-cutting. I would also suggest, at first, that you make exposures both with the second light and without it. Never experiment with new techniques at a wedding without first getting the images you need with techniques you are very familiar with.

I use the Quantum 4i Radio Slave to trigger the second light. The local and remote switches on the transmitter allow you to turn the lights on or off at the camera without affecting the other light.

Of course, using great equipment and film does not guarantee great images. An investment in education is crucial. I have been studying with top photographers from around the country since 1972. You should join local, state and national photographic associations, and attend meetings whenever you can. The Professional Photographers of America and its affiliates offer weeklong seminars around the country that you can and should attend. Wedding and Portrait Photographers International is another fine organization. See the resources list at the end of this book for contact information.

Crystal Clear

Without a second light, this ice sculpture would have appeared quite bland. In this image the second light, placed right next to the ice sculpture, illuminated the vase, showcasing its wonderful detail. I used the 50–watt-second setting, the lowest setting on the flash. In this instance, the second light (a Lumedyne flash unit) was used for special effect. I set the camera at f8, then used the on-camera flash as usual.

The on-camera flash I prefer is the Quantum Q. I have had excellent results with it, as well as with the Quantum Q 4i Electronic Slave, which has also performed exceptionally well. It has local and remote on/off switches, two channels and a high and low speed. It only requires one nine-volt battery to power the transmitter, and four AA batteries for the receiver. This unit controls both the on-camera flash and the second light, and will allow you to fire each flash independently or to trigger both simultaneously. You can also use an optical slave, which "sees" the light from one flash, and subsequently triggers the second light. I always carry an optical slave in my camera bag. The downside with this particular piece of equipment is that any flash can trigger it, which means that if someone else makes a flash exposure, your light will go off with his or her flash.

second light at 50 watt seconds
(used as a special effects
light in this situation)

Hasselblad camera
120mm lens
set at f-8

Quantum Q-Flash
set on automatic f-5.6

This image lends itself well to another discussion important to wedding photography: marketing. One of the best ways to market your services is to give photographs to the various vendors present at each wedding you shoot. Take and print images for the flower shop that made the bride's bouquet and for the wedding consultant, bridal and tuxedo shops, caterer, the director of the reception hall, etc. I sometimes also photograph the interior of the sanctuary if the decorations or layout are different than usual for the particular place of worship. That way, they can show brides the different ways their location can be set up or decorated. Make sure you sign or stamp the front of these images and place a label on the back with your name, address and phone number. By consistently providing your contacts with complimentary images, you can stand out from the competition. This is a great way to generate business by ensuring that future brides will see your photographs and your name at every step of planning their wedding. You may also receive referrals from vendors—after all, brides often ask for advice on selecting a photographer from those professionals they meet along the way.

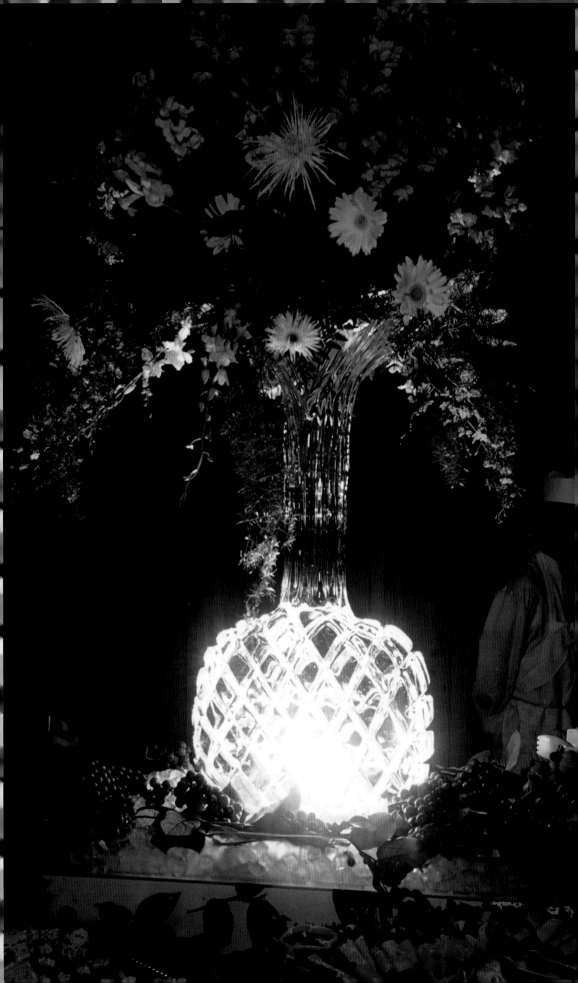

Remember, there are hundreds of special details that have been carefully planned in every wedding—flowers, centerpieces, details of the bride's dress, ribbons, etc. Both close-up and full-view images are needed. A lot of time and money is spent on these details. Record them!

I do a lot of twin lighting on these images because it adds detail to these smaller subjects. Use all the lenses in your toolbox for lots of different views. I like to use a 120mm lens on my Hasselblad when capturing these details because of its close focusing ability.

I do a lot of twin lighting on these images because it adds detail to these smaller subjects.

It is very important to ask a lot of questions, listen and take notes when you visit with your clients. Ask probing questions that will give you a feel for the type of images your clients expect. Find out just what is in the bride's heart, and what dreams and fantasies she has about her wedding day.

Listed below are just a few of the questions I ask to find out what type of images the bride envisions.

- What type of wedding will you be having?
- What type of photography do you require?
- What is your vision of the wedding?
- Who will be attending the wedding?
- What do you want your wedding to look like?
- If you could get exactly what you wanted, what would it be?
- Why did you decide to have your wedding at this church?
- What do you envision as the sequence of events at the wedding?

second light at f-8 (used as main light in this situation)

Quantum Q-Flash set on automatic f-5.6 Hasselblad camera 80mm lens set at f-8

A Special Moment

Both the bride and groom brought three children to their marriage, and the kids played a very important role throughout the entire wedding day. Again, my job was to capture their view of the wedding. This wonderful image captures the spirit of their uniquely special event. My favorite part of this fun image is the littlest guy standing in front of the groom. He seems to be saying, "Need some help?"

The children are the props in this image. Each one has an expressive look on his or her face. Without the children, this would be just another cake-cutting photograph. I feel that it is very important to look for and capture special moments like these; they tell the special story of the wedding. Every wedding has its own personality, and you must be sure that unique personality shows in your images.

I used twin lighting to capture this image. If you look carefully, you will see it. The lighting used here gives direction but is not overpowering. The light was kept high to prevent shadows from falling on the background and the children.

As a photographer, you have got to be sure that you are always prepared to capture a great story. Once more, what do the bride and groom want from you? They want you to perfectly capture their memories—their whole wedding, just the way they dreamed it would be! Working with the bride's ideas and style, we custom design a wedding album that tells the story of her special day.

Without the children, this would be just another cake-cutting photograph.

second light at f-8
(used as main light
in this situation)

Quantum Q-Flash
set on automatic f-5.6

Hasselblad camera
80mm lens
set at f-8

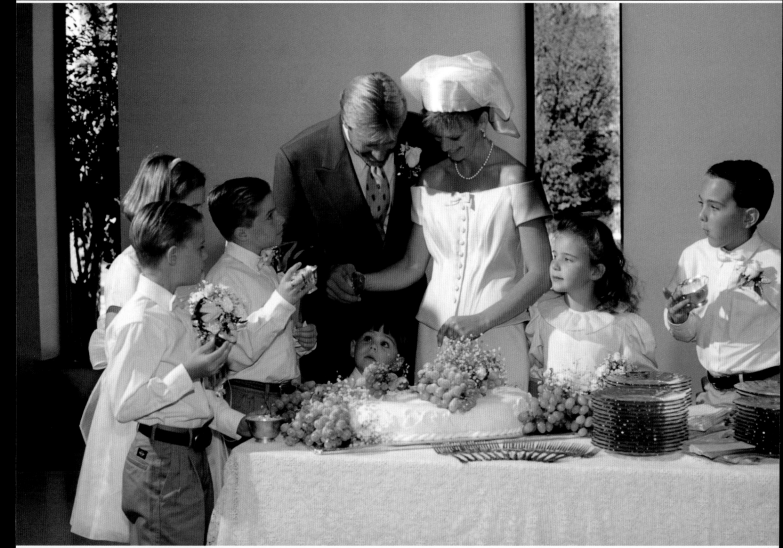

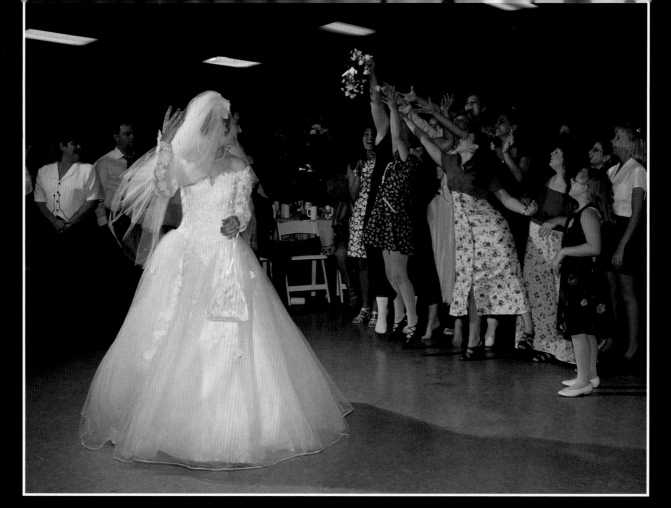

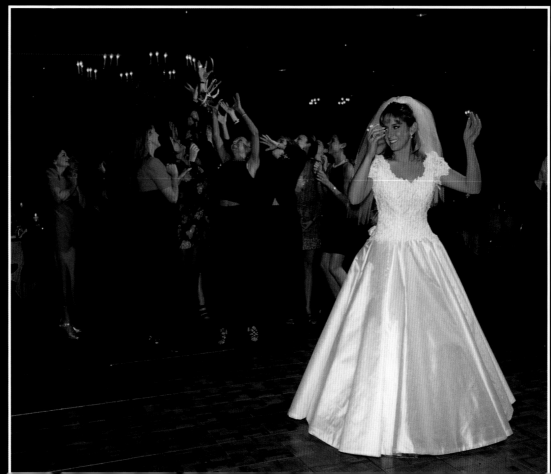

I positioned the bride and single women so that I could see them all for the image. I have seen some photographers that break this into two images—one shot "faking" the tossing of the bouquet, the second shot showing the ladies trying to catch it. I chose to make one image that captured the whole event as it actually happened.

In this twin lighting situation, the on-camera light was used as a main light on the bride. It also added some much-needed fill light on the group of women (because this light was placed farther from the girls than from the bride, the light on them is less intense. The inverse square law states that the light falloff is inversely proportional to the distance the light is from the subject.)

The second light, another main light, was used on the group, but the illumination it provided also skimmed across the bride. Without this second light, the single ladies would have been a stop or more darker than the bride. The camera and both lights were set to f8. The shutter speed had no real effect on the image except to control the background. A slower shutter speed would have recorded more of the background, as it would have allowed more ambient light to hit the film. A faster shutter speed would further diminish the background.

There are several ways to approach shooting any event. I don't pretend to believe that my way is the only way. The images in this book simply provide the inspiration and techniques you need to make some of the hundreds of images typically made at weddings. In my twenty-nine years creating wedding photography, I have done many of these images lots of different ways. I approach each image with numerous considerations in mind: my past experience with various techniques, the opinions of brides I have worked for, feedback from suppliers I have worked with, lessons from photographers/speakers I have seen and studied with and my own tastes and opinions. Remember, the bride selected your services based on *your* style, so be sure to deliver what she expects as the wedding unfolds.

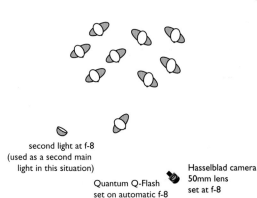

second light at f-8
(used as a second main
light in this situation)

Quantum Q-Flash
set on automatic f-8

Hasselblad camera
50mm lens
set at f-8

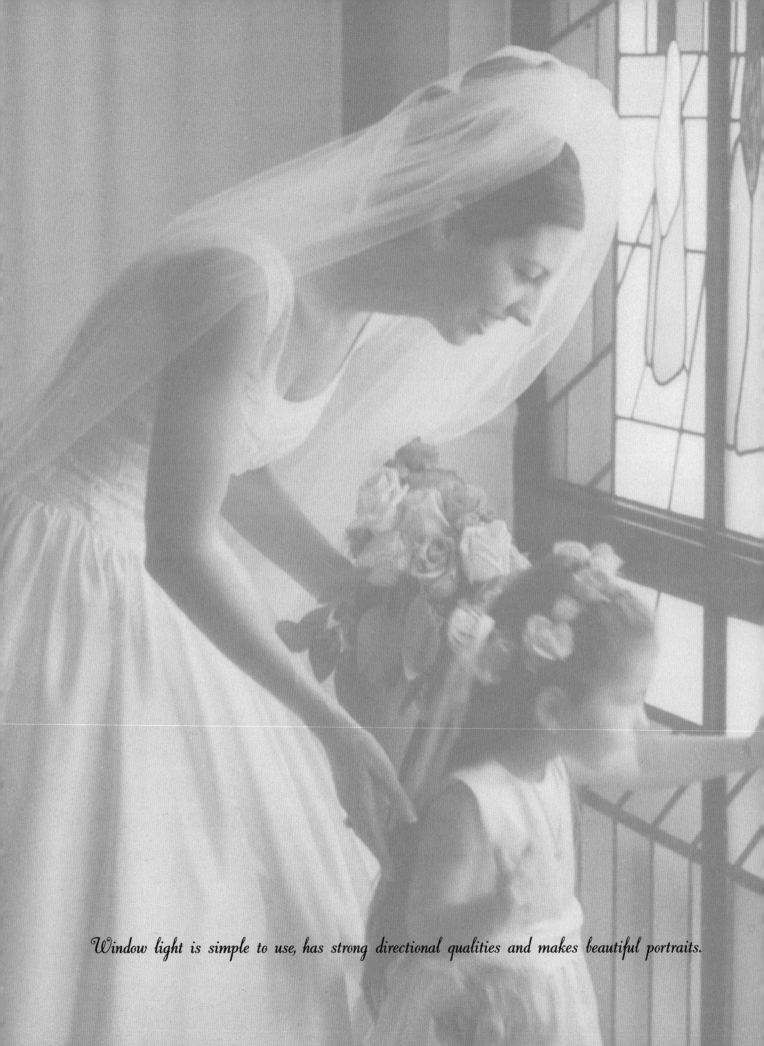

Window light is simple to use, has strong directional qualities and makes beautiful portraits.

WINDOW LIGHTING

Using window light is a simple way to increase the variety of your wedding-day portraits.

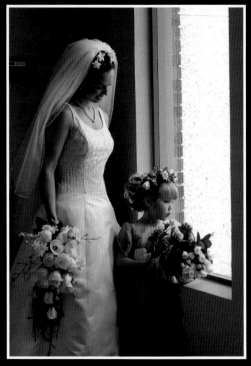
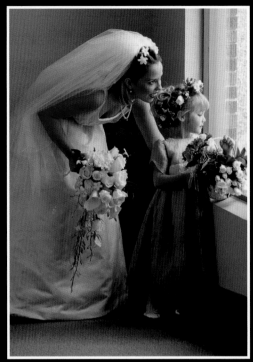
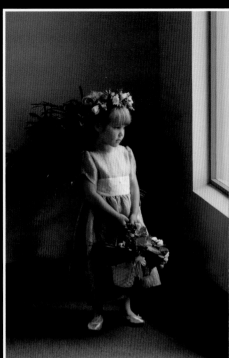
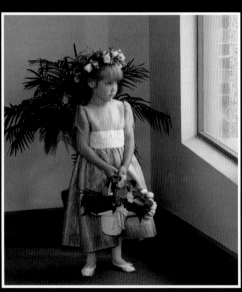
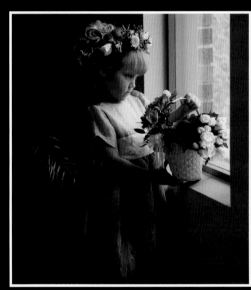
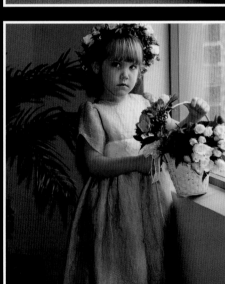

For the first image of the bride and flower girl by the window, I used the flat disk mode of my incident meter and took a reading at the bride's face, pointing the disk at the light source, which in this case was the window. Metering in the flat disk mode *is* harder, but it is more accurate if you are careful. (If you are not particularly careful when metering, I recommend using the dome.) In this instance, my reading dictated $\frac{1}{60}$ at f8. I backed up, set the exposure and took the image— I did not use flash or a reflector to create this image.

In the second image, the bride just sort of bent down to give a little variety in the image.

The third image shows the flower girl alone. I like this one a lot. By moving her away from the light source, the contrast isn't as intense as it appears in the other images. In the second image of this little girl, I turned the flash on; its output was about a half-stop less than the light coming from the window. While you can still see a little bit of the ambient light that came in from the right side, I think there's a little too much flash in this image.

The fifth and sixth images are close-ups. In the fifth, the girl looked at the light source. I took a meter reading at her face and took the picture.

When the girl looked at me in the sixth image, the window produced split-lighting; half of her face was lit, and half was in shadow. Had I not turned on the flash, half her face would have remained dark, and half light. I set my Quantum Q-Flash at two stops under. I knew from experience that this would give me $1\frac{1}{2}$ to $1\frac{1}{3}$ less light than that coming in from the left. Here, the meter reading was $\frac{1}{60}$ at f8, and I set my flash at f4 (you'll have to work with your own equipment and see not only how much flash you get, but what you like). My on-camera flash served as a fill light, and I was careful not to over-fill the image.

Many photographers set their flash to match the meter reading. When their meter reads $\frac{1}{60}$ at f8, they set their flash to f8, and the resulting image is cut-out looking and very amateurish—the light comes from the flash, overpowering the ambient light. In the last image, you can see that one side of the girl's face was illuminated with window light, while the light on the shadow side came from the flash. The result is a more balanced, toned-down and natural-looking image.

Metering in the flat disk mode is harder, but it is more accurate if you are careful.

Warmth and Spontaneity

In the room where this image was composed, there was a tall, narrow window that proved to be a very small light source. I knew I could expect a nice quality of light because the window looked out on an open sky with no direct light coming in, so I decided to work with the available light.

I first positioned the groom in sort of a macho pose, then had the beautiful bride come up and sort of snuggle with him. She stood off to his side and a bit behind him, and while the pose was nice, I noticed that there was not enough light hitting her face. There was quite a bit of difference between the amount of light that was hitting his face and that falling on hers. All I had to do to remedy the situation was to have her lean her head in somewhat to catch some of the light. This minor adjustment produced a very special image. The image is filled with warmth and truly seems candid—I love the way it turned out.

As we have discussed, photojournalistic images capture real emotion and unscripted moments as they unfold, while more traditional images are composed to achieve a specific look. A third style is represented in this image; it's a "posed candid." While it was posed, the photograph still has a spontaneous feel.

. . . while the pose was nice, I noticed that there was no light hitting her face.

window

Hasselblad camera

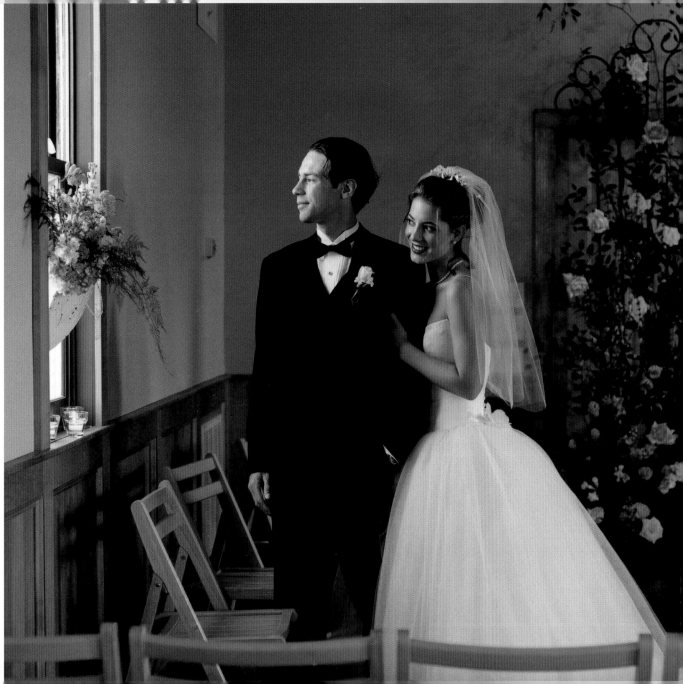

Love and Support

In this location, there weren't many windows available to produce widow-light techniques, so I used a doorway to create the effect. After all, while the number of windows in a church vary, every church has a door! You want to make sure that when you look out the door, you see some blue sky so you get some open sky lighting, not just light that's bouncing off the trees.

To get the exposure for the first image, I took the light reading at the bride's face, pointing the incident meter toward the door. Remember, you can control the contrast by varying the bride's position in relation to the door: the closer to the door, the higher the contrast (the shadow area goes darker); the further from the door, the lower the contrast. As the bride's position changes, you'll need to remeter to ensure proper exposure.

In the image of the bride and her mom, the bride is looking at the camera. In this case, I didn't use the flash; I simply forgot to turn it on, but reshot the image to illustrate how using flash affected the photograph. Quite honestly, there was a split lighting on the mom and an almost split-lighting pattern on the bride. To me, this image is not as flattering as it could have been.

While I don't have perfect lighting on the bride's face in the portrait of the bride and her dad, I do have very nice lighting on the dad. I particularly like the way this image turned out: the dad is the primary subject in this case, and I enjoy the relationship between the two. If I wanted to, I could have added a little flash to fill-in the light on the bride's face.

In the family portrait, the subjects were positioned in the same spot, but I've used flash to fill-in the spaces. Here, the use of flash opened up the eye sockets as well. The window light, the main light in this situation, lent a nice quality to the image, and though flash was used in this particular image, there's still a sense of continuity in the lighting of this series of images. As you can see, I could easily combine these images on a single page of the couple's wedding album.

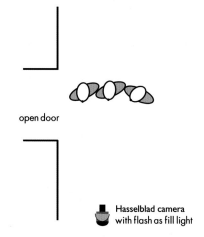

open door

Hasselblad camera
with flash as fill light

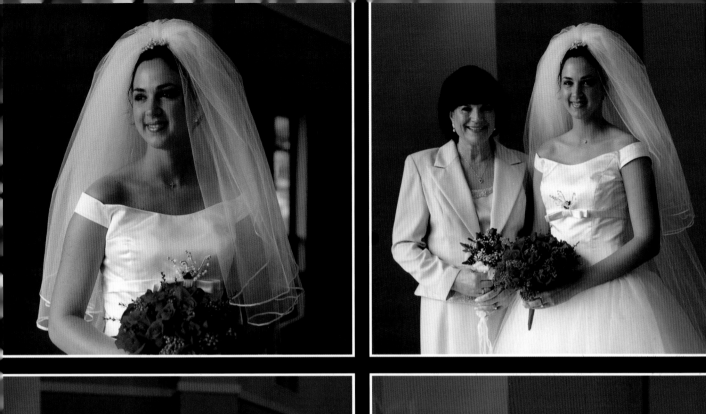
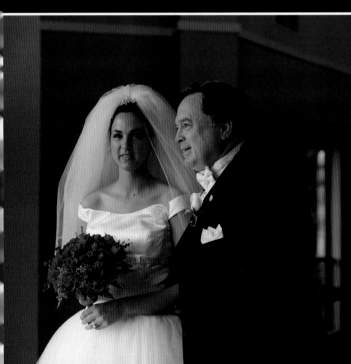
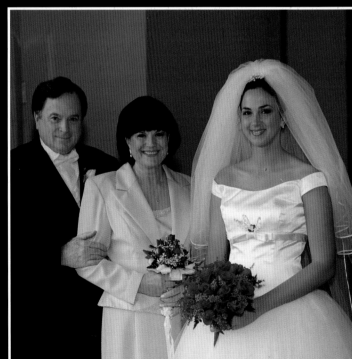

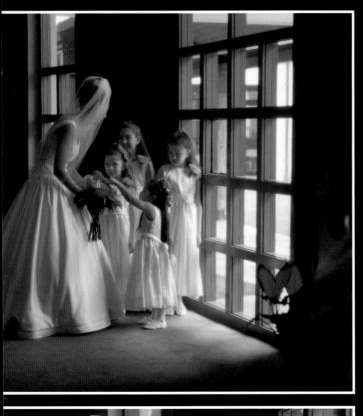
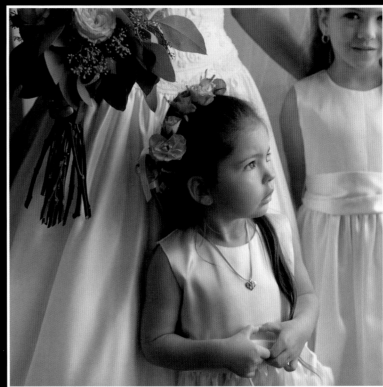
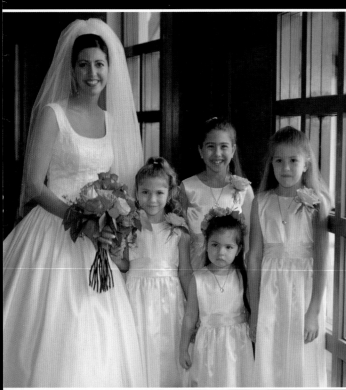
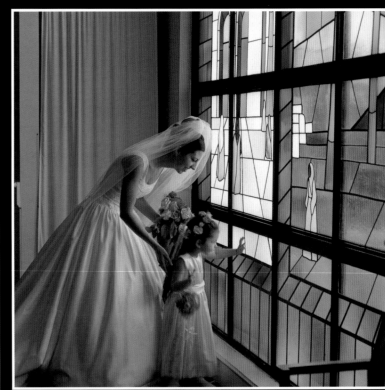

In the first image, I brought the four girls and the bride over to the window and positioned the camera fairly perpendicular to the wall, and a little over toward the left, just to pick up a little light from outdoors. I took a meter reading at the subject, pointing the meter at the light source. I love the image. There's a lot of drama and fun here, and it looks as if I've captured a candid image.

There's a lot of drama and fun here, and it looks as if I've captured a candid image.

In this second image, which is a nice take on the first, the main subject is the little girl, though there are secondary subjects in the background. To get this picture, I slipped a 250mm lens onto my Hasselblad and, from basically the same position, photographed the little girl.

In the third image, I had all of the girls look up at me and placed them so I'd get a nice portrait. If I didn't use flash as a fill light here, I would have had very dark shadows on one side of the subjects' faces. I set the camera at ¹⁄₆₀ at f4, then turned the flash on at two stops under to capture this image.

The final shot was taken at a different window in this church; it adds a little variety to this particular group of images. I enjoy the interaction between these two subjects. Again, by taking a meter reading at the subject, with the dome pointed at the light source, I achieved a nice light on both the subjects' faces and beautifully captured the stained glass, which is neither too dark or too light.

stained
glass
window

Hasselblad camera
250mm lens

Silhouette

When there is more light on the background than on your subject, you'll get a silhouette. When the couple pictured on the opposite page was about to walk through the door, I had them pose at the threshold. If I had moved them outside the door, there would have been too much light hitting their faces and I wouldn't have gotten a good sil-houette—just bad subject lighting. By keeping them inside the door-way, where there's almost no light hitting them, then setting the cam-era for the ambient lighting outdoors, I was able to get a properly exposed photograph outside, and kept them totally dark.

It was a very sunny day, and the sky was blue, so I used the Sunny 16 rule to get the right exposure for this shot. In this instance, I was using ISO 400 film, and set the shutter speed at $\frac{1}{500}$, as this is the clos-est I could get to 400. I set the aperture at f11½, which gave me a perfect exposure of the background. The couple went dark, as there was very little light on them.

For the second image, I had to determine how to set the exposure for the stained glass. There is no constant exposure rule for stained glass. Each type emits a different amount of light, so you'll have to recalculate your exposure each time. I took a spotmeter reading of the medium-blue glass in the left-hand corner of this particular window, then proceeded with the shot. Metering red and medium-green glass also tends to work well. The trick here is to meter something in the mid-range—nothing too light or too dark.

When there is more light on the background than on your subject, you'll get a silhouette.

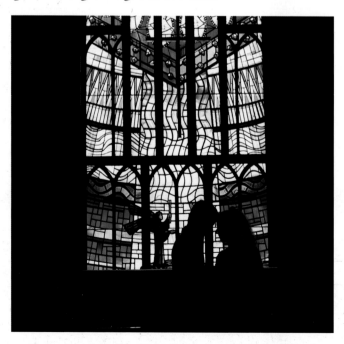

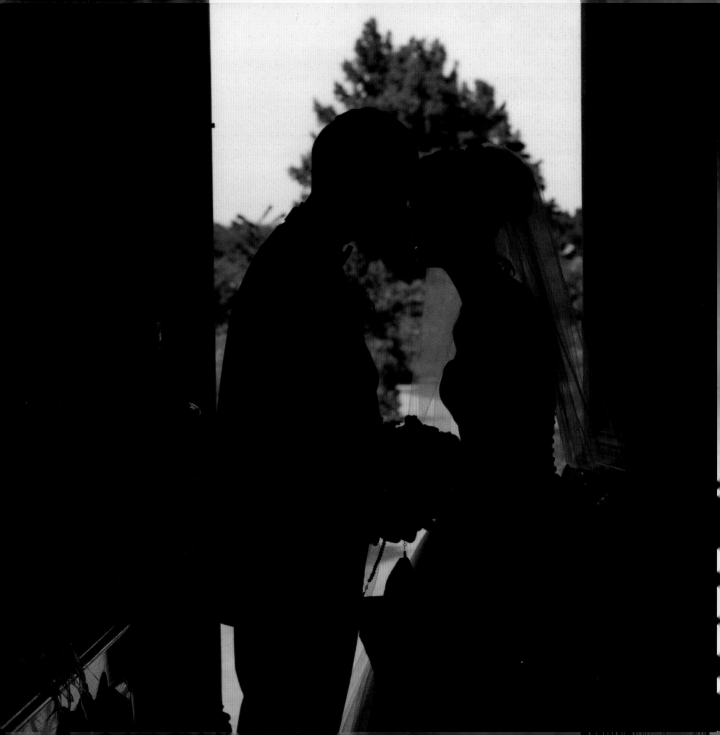

A Cherished Portrait

When I noticed the strong light coming through this beautiful window, I knew that it would make a great background for a bridal portrait series.

In the first image, the bride is in profile. Take a close look at the lighting on her face. Do you enjoy this style of lighting, or is too contrasty for you? If you are producing an image like this and the light is too strong for your taste, you can easily soften the effect by adding a little fill. For this image, I set my camera to $\frac{1}{60}$ at f8. No flash was used, because I wanted to produce a dramatic look.

In the second image, the bride was in the same position, but I moved the camera perpendicular to the window. Again, we pointed the light meter at the window, and achieved a reading of $\frac{1}{60}$ and f8. To some people, this image is too dramatic.

In the bottom image, I set the flash to f4, approximately two stops less than the highlight side, to fill-in the shadows.

Again, creating a series with various exposures will provide you with a variety of images to choose from when it is time to create the client's wedding album.

If the light is too strong for your taste, you can soften the effect by adding a little fill.

Hasselblad camera

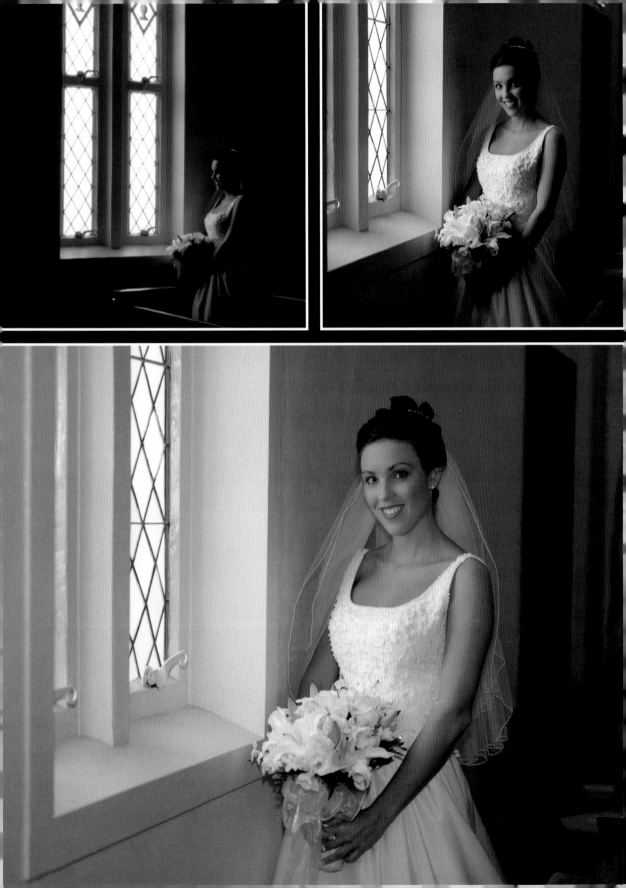

Strength

This pose is simple, comfortable and believable. When posing, always start with the feet. Weight should be placed on the back foot, which is typically turned at a 45-degree angle from the camera. With the weight on the back foot, the front knee usually bends, and the back shoulder drops slightly. This relaxes the body and keeps subjects from appearing too straight and stiff.

When posing men, I like to have them tilt their heads slightly toward their lower shoulder, creating a C shape through the head and the body. Here, the groom's left hand is in his pocket; his right hand is extended to rest on the back of the pew. Both of these gestures reinforce the C shape and emphasize the subject's apparent comfort.

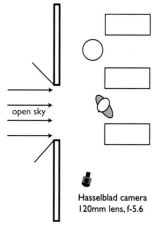

open sky

Hasselblad camera
120mm lens, f-5.6

In this particular image, we showed the groom's full face. "Full face" is defined as showing both sides of the face equally. I usually photograph only three views of the face: full face, ⅔ view and profile.

This Catholic church in Brenham, Texas, is a great place to photograph because of its architecture and numerous windows. I wanted to show the sanctuary as the background. Notice that the groom's head is positioned against a plain part of the background; I moved the camera to keep the lines of the background from intersecting with his head. The camera placement also shows the column, which adds strength to the images and nicely contrasts with the groom's dark tux.

The architecture seen in this image was a real treasure. The open doors provided much of the light for the image. Metering the shot was simple. I placed the meter near the groom's face, and pointed it directly at the camera. By pointing the meter at the camera, both the main light (coming from the door) and the fill light (overall illumination in the room) were factored into the reading.

You have to earn the respect of the people you photograph. This is especially important at a wedding. You need the cooperation of the participants in order to do your job well. If the people you will be photographing respect you and your work, they will be cooperative and make your assignment easier. Treat them with respect and don't be bossy. Take control, but in a nice way.

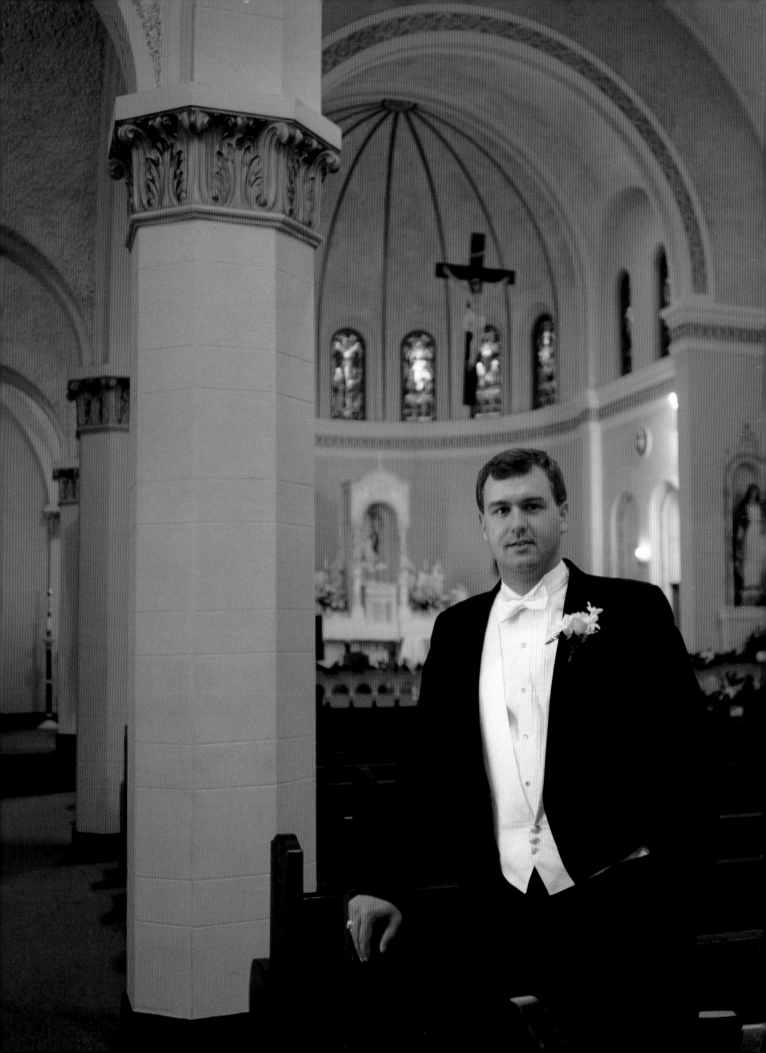

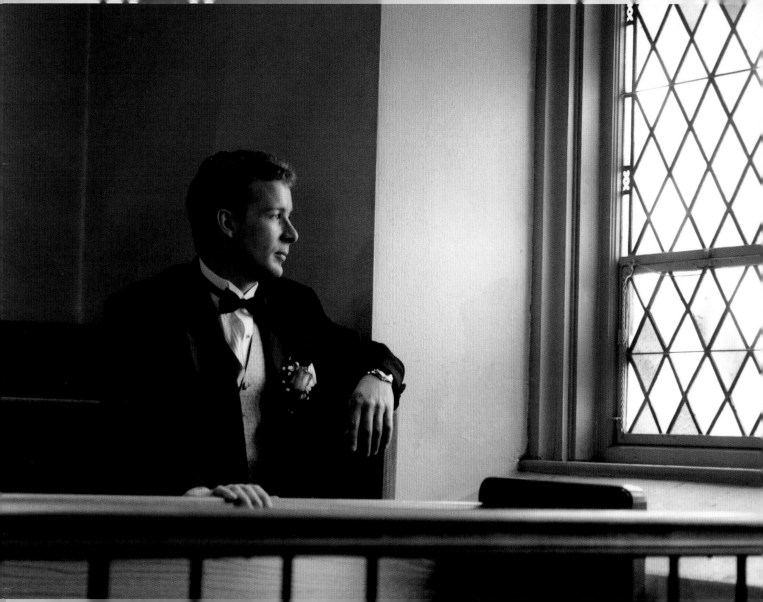

A good pose is usually a comfortable one. If the person feels comfortable, he or she will appear that way on film, creating a "stolen moment" sort of image that seems anything but posed. When working with clients, I generally model the pose for them before asking them to get into position. I like to know that the clients will be comfortable in the pose I've asked them to assume. Next, I suggest that my clients repeat the action. That way, I know the pose will look good.

The balcony of this church provided a quiet, secluded area for a serene portrait of this groom. The beautiful window found there provided an almost lyrical quality of light. The area seemed to exude peacefulness and serenity.

Of course, metering in an area like this can be tricky. Do you meter the window, or the shadow of the face? Experience has taught me that if I use an incident meter, place it at the groom's face and point it straight toward the light source, it will give me a good exposure. You must know how each film will react to different kinds of light. Consistency is important—this is one of the reasons why I love and use Kodak film.

I respond to people on an intuitive basis. It's a talent that comes from years of observing people, and it is an important skill for a wedding photographer. A photograph encapsulates a moment in a person's life. Here, I wanted to capture this quiet moment just before the groom was about to take an important step in his life. Instinctively, I felt I had created the image I wanted.

The balcony of this church provided a quiet, secluded area for a serene portrait of this groom.

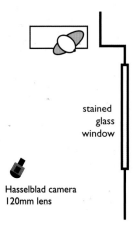

stained glass window

Hasselblad camera
120mm lens

A Time to Remember

For the photograph with the bride, groom and children, I brought the four subjects to the door and simply asked them to look outside toward a particular tree. It is important to give your subjects something to look at or everyone will look in a different direction, which will be distracting in the image. I enjoy the ring bearer's feet in this image—he must have been comfortable with me to pose himself in such a natural way.

In presenting these three images, I wanted to prove that if there is an opening for light to come through, you can make a very nice window light portrait. In fact, I created the striking image of the bride by posing her near a simple 3x4-foot aluminum window. The light on her face is beautiful, and that same light also shows great detail in her gown.

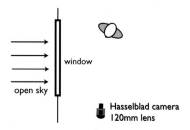

In portraiture, the position of the face in relationship to the light is very important. In the group portrait, each of the faces are beautifully lit; however, if the four subjects had looked at the camera, an unflattering split lighting situation would have resulted. The contrast of the light would not have changed, but that contrast would have been too great considering the position of the faces in relationship to the light.

In the portrait of the little girl and boy, light was coming through a doorway in the foyer of the church, which had great brick walls. With the addition of a nice painting and a green plant, I had all I needed to create a very nice photograph.

Being a professional photographer means *no excuses.* It doesn't matter if it rains or shines—whether it is sunny or cloudy, your job is to create beautiful images. In all three of these images, I found a location with soft, indirect light. If you can find a doorway or even a window in an office space, you can create beautiful images.

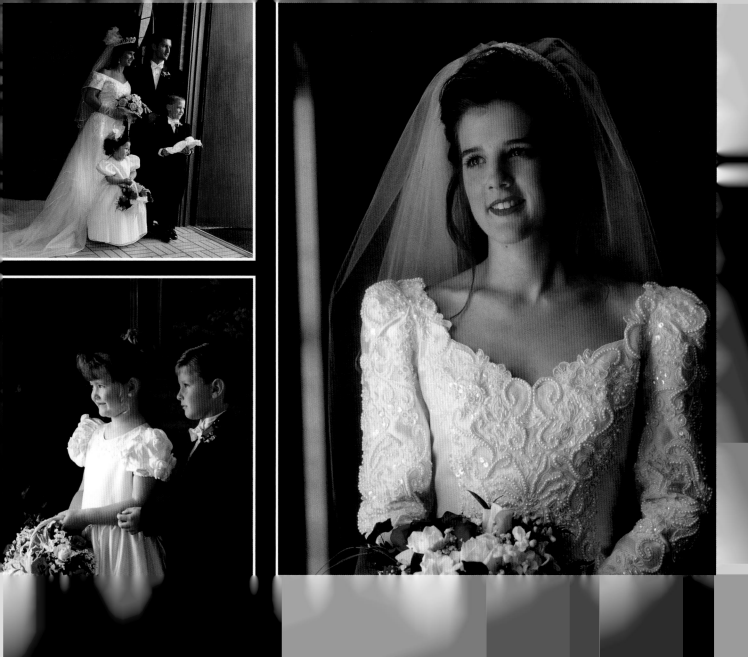

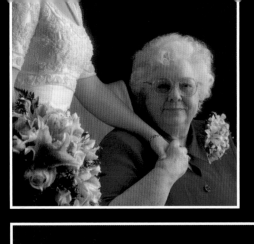

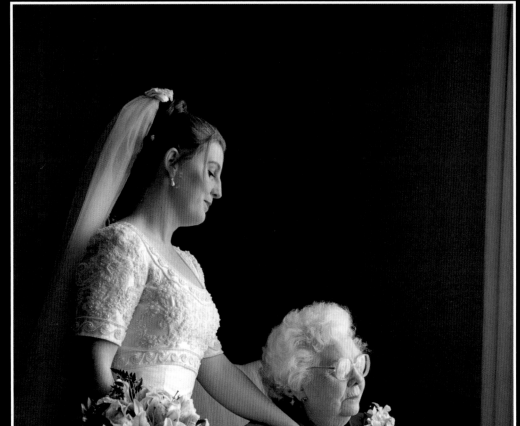

Again, the pose for this image is very natural. The bride is shown standing, holding the hand of her grandmother and looking out the window. I sat the grandmother in a chair at the back side of the window (that farthest from the camera). I brought the bride over, and she naturally placed her hand on her grandmother's shoulder. Then her grandmother simply took her hand. The pose used here is simple, innocent and meaningful.

Sometimes multiple images tell a story better than a single photograph. In the close-up image, the face of the bride is not shown; in my opinion, it is not needed. The important part of the image is there—the love between these two people. The first image nicely sets the stage for the second one.

This image also shows how a simple window and a non-distracting background can make for a dramatic photograph. No flash or reflector was needed to create this beautiful portrait. I love the way the bride is looking down at her grandmother.

Many older women do not want to have their photograph taken, or at least they say they don't. I just talk very sweetly and ask if I can call them Grandma. Then I take them by the hand and ask if they will just have a seat over by the window. I also photograph grandparents alone. It's a great time to get images of these special people.

A simple window and a non-distracting background can make a dramatic photograph.

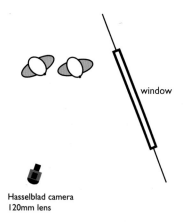

window

Hasselblad camera
120mm lens

A Closer Look

Both of the images pictured on these two pages were made with natural light, and the metering was the same for each: I simply pointed the dome toward the light source. Details like these make every wedding different and special, and capturing them ensures that these details will not be forgotten in time. Always look for little touches that the bride has included in her special day. You'll find that the bouquets you come across will vary from wedding to wedding, yet they are always beautiful and, more important still, they are special to the bride.

Don't feel that photographs must have flash added to be good. These images were made with no added light—only window and available light. You can see the direction of light in both of these images; it adds roundness and dimension to both images.

Always look for little touches that the bride has included in her special day.

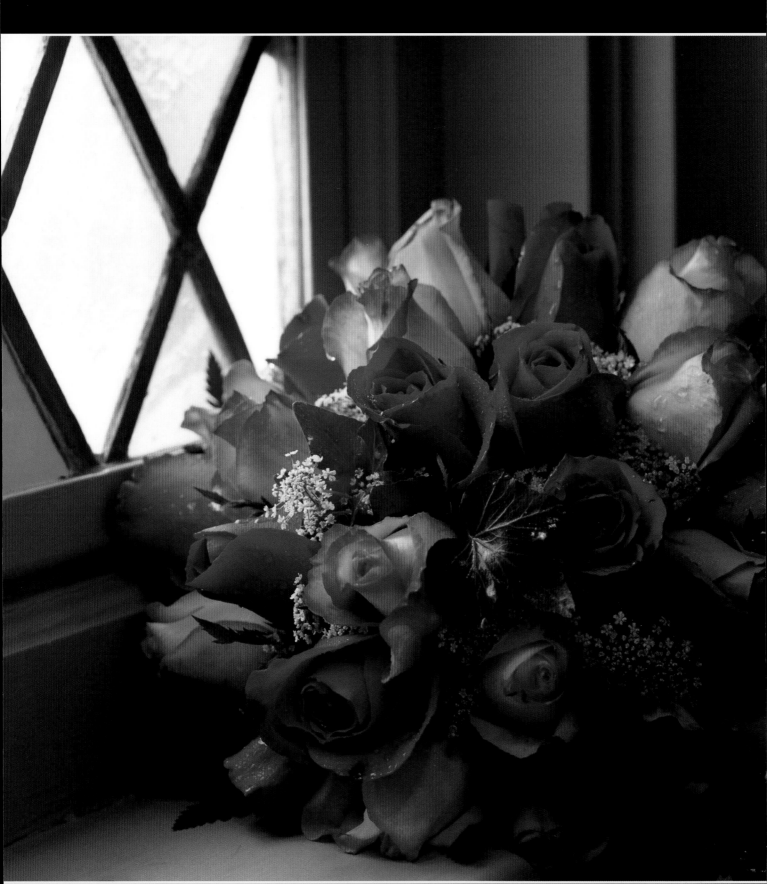

Today's Love, Tomorrow's Life

I began with the bride at the window, creating a profile photograph of her in this position. Then I simply moved the camera closer to the wall. The bride did not change her position, but only raised her face a little. The groom was then brought in beside her. If you place the subject to create a good lighting pattern in a profile view of the face, you can move the camera to photograph a ⅔ view of the face and still have good light on it. In fact, if you are able to position the camera to photograph the full face, the light will also be good there. The key is to place the person so that the light is at about a 45-degree position from the front of the face.

The window is really the background. Many photographers are amazed when the light source is in the photograph, such as in the image of the bride alone, and the highlights are not blown out. Here, the window still has detail and so does the highlight on the bride.

stained glass
window

Hasselblad camera
120mm lens

Again, I pointed the meter at the light source (the window) and made the image. Look at the light in the eyes of the bride and groom. Also look at the way the light sculpts the beautiful shape of the bride in the profile image. I am surprised that many photographers don't do window light images at weddings or add flash to an image like this. You can make great photographs with window light alone, if you learn to use it properly.

I like to use Kodak Portra films to shoot weddings. First, all films in the series perfectly match each other in color rendition. I can use these films in any combination and put the photographs in the same album, and the colors will match. Second, these films have excellent exposure latitude; they can handle an incredible range of over- and underexposure. I have run tests and can get very good images with negatives two stops overexposed to two stops underexposed. In fact, during a test session, the flash did not fire on one exposure, and the only illumination was the small amount of ambient light in the room. The resulting image was four stops underexposed. To my surprise, I still got a fairly good image. It was not a great photograph, but if this had been the only image of someone important at a wedding, it would have been acceptable. The way I look at it, using this film is like having a backup photographer along with you at every wedding. Finally, another important reason for using Kodak film is the Promise of Excellence program, through which Kodak guarantees the images against fading. Contact Eastman Kodak for more information on this program.

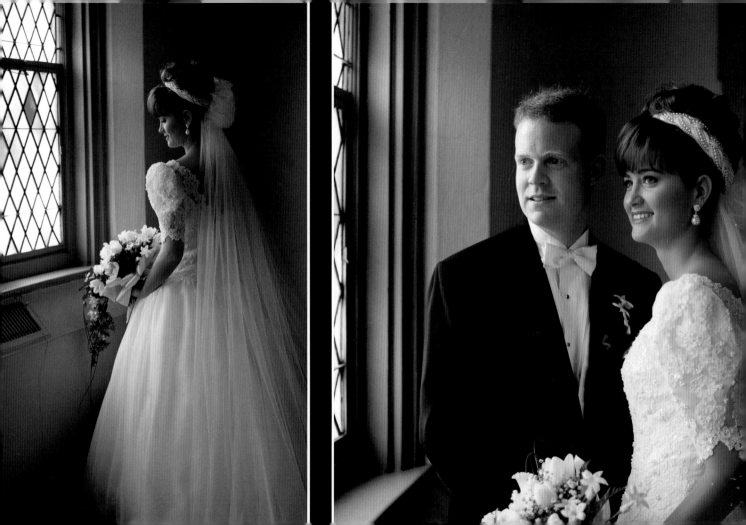

Peeking

As I've shown throughout this book, if you leave children alone, they will probably pose themselves. This pose shows the boys' excitement about the day. Young boys are so cute because of their curiosity. These boys played an important role in their mom's wedding, and they took their roles seriously. This photograph shows both their curiosity and seriousness.

window

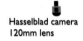

Hasselblad camera
120mm lens

The young men were seated on a built-in seat in front of a large window, and the light coming through it illuminated their faces. I used a 120mm lens on my Hasselblad to capture the shot. The medium telephoto lens allowed me to back away from the subjects a little, and prevented the distortion that sometimes comes from using a normal or wide-angle lens for close-ups. I placed the faces in the top right-hand corner, leaving space in front of them, which lends a comfortable feel to the image.

When young boys reach this age, they are torn between being boys and being men. Do they goof around or act serious? I find that talking with them like they are adults earns me more cooperation than acting like they are kids. It's important to treat your clients with respect.

No matter who you photograph, a wedding coordinator provides an invaluable service to brides—and photographers; they keep everything running on time. Do yourself a favor and get to know the other professionals who the bride has hired for her wedding. There's nothing better than a personal recommendation from another vendor in the wedding business—brides trust their opinions and often follow their advice.

As I mentioned earlier, I make photographs for the vendors I work with, providing them with images for their sample albums. Of course, I gold-stamp my name on the front of the photograph and place a label with my studio information on the back. In some instances, I have made complete albums for particular vendors.

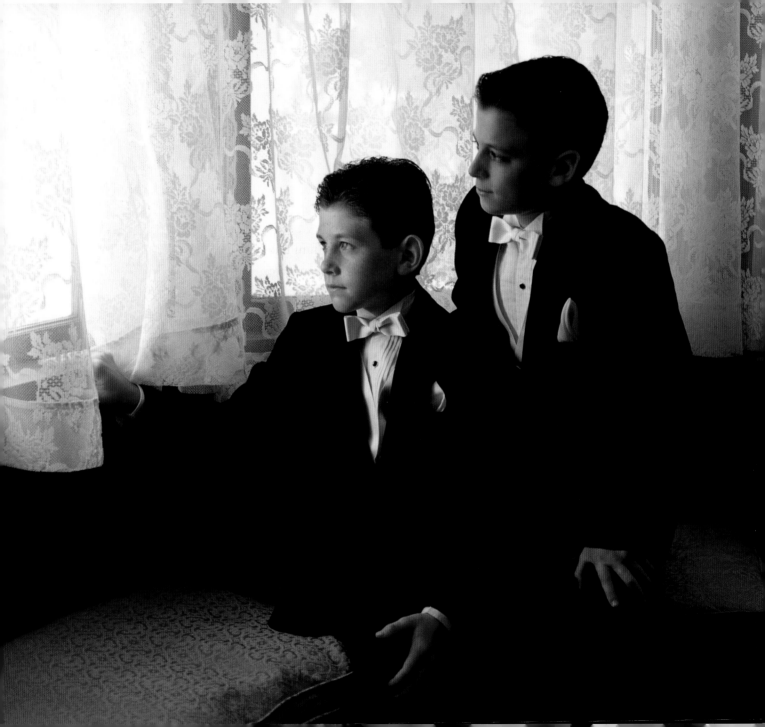

AVAILABLE LIGHT

Available light can come from a variety of sources, from light fixtures, to windows and candles.

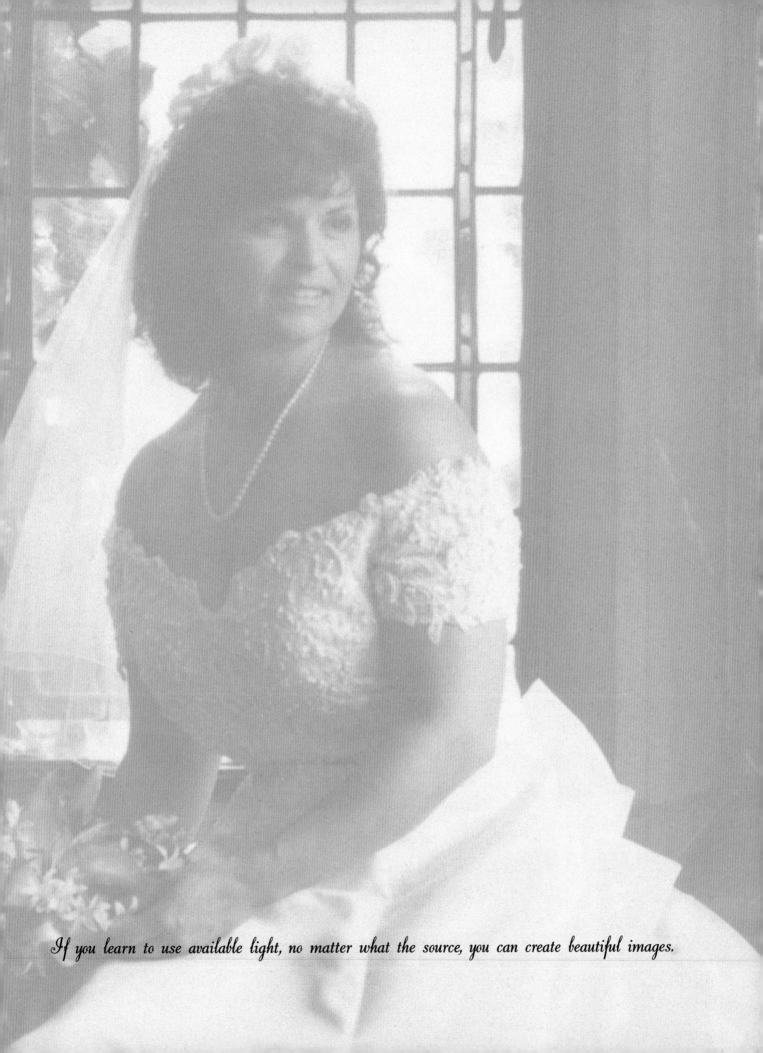

If you learn to use available light, no matter what the source, you can create beautiful images.

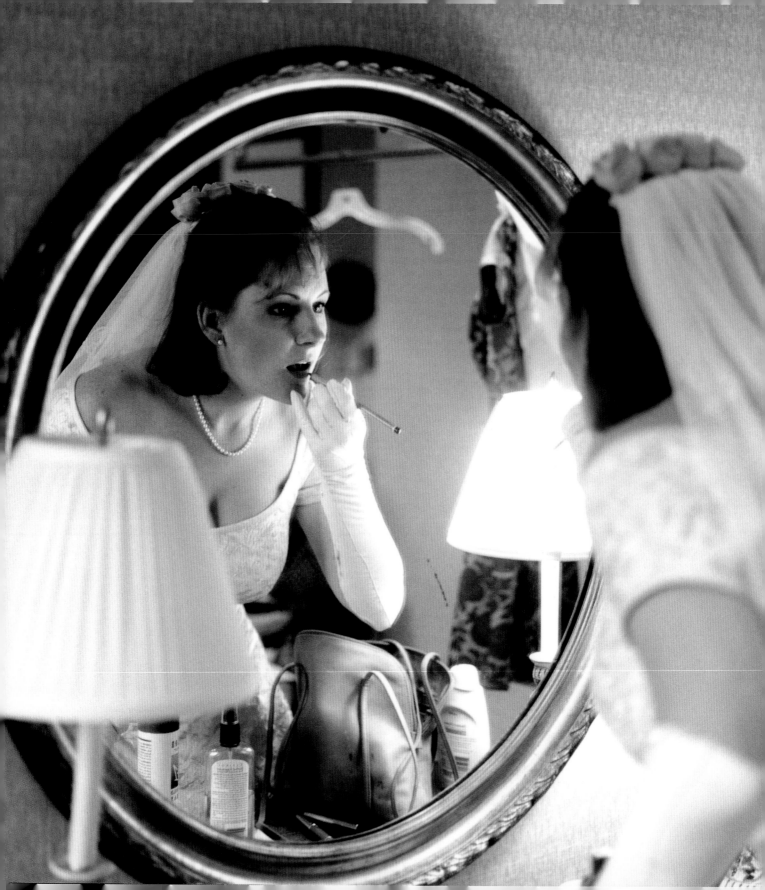

Hasselblad camera
120mm lens

One of the choices you need to make when using available light is what film to use. I use both black & white and color film for available light images. The black & white films I use are Kodak TriX and TMax 400 speed, and Kodak TMZ 3200 film for 35mm. The latter I rate at ISO 1600 and process the film at 1600 to create a beautiful soft grain pattern. For color, I use Kodak Portra 400 and Kodak Portra 800 in medium format size (120 and 220). The 800 speed is an amazing film. The extra speed allows you to use faster shutter speeds, while still achieving a very nice grain structure. I have made some great images using this film, even in enlargements of 24x30 inches.

While photographing a wedding, I did a series of images of the bride getting ready. These were not posed, just captured the way they happened. I saw this image unfolding as the bride made some last-minute touch-ups to her makeup. I enjoy images in a mirror if they occur naturally, but think they seem a little silly when they're posed.

I love the way the light in the mirror illuminates this bride's face. It adds so much realism to the image. In situations like this one, I use wide apertures to isolate the subject and to allow for faster shutter speeds. I find this especially helpful whenever I have to handhold the camera.

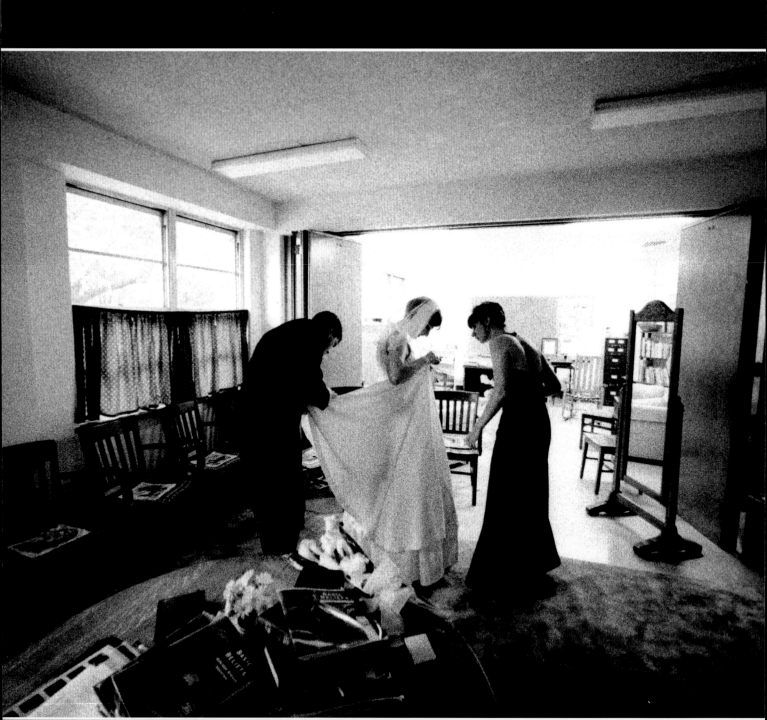

These images depict some of the behind-the-scenes moments that occurred on this bride's wedding day. It was raining, and this cute image nicely captures that aspect of the bride's day.

In the image on the opposite page, the bride and maid of honor were bustling the gown. One of the loops needed to be expanded, and they couldn't fix it, so the groom was summoned to help. Again, this image was unposed; I just captured the event as it naturally unfolded. The photograph was made in black & white, which was a perfect choice for this image. Here, the black & white film keeps your attention off the clutter and on the subjects and the action.

This image was unposed; I just captured the event as it naturally unfolded.

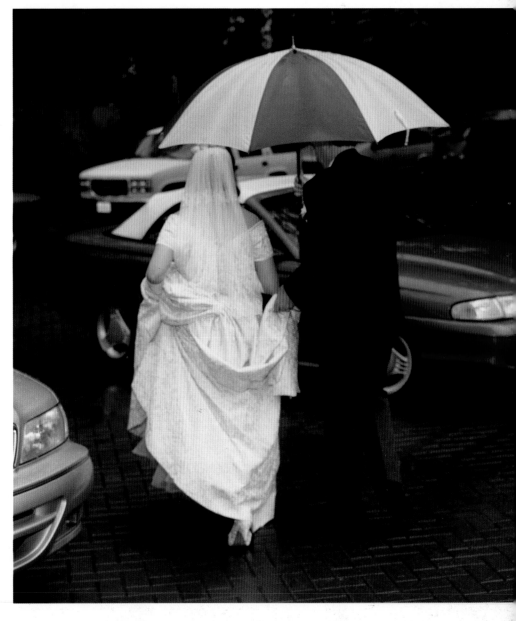

Brides want you to document the emotion of the day. Every wedding has its own personality; I try to capture its unique flavor in my images. Some weddings are elegant, some are casual. Whatever the case, show the joy and happiness of the couple, their family and friends. These moments are not posed, they are found. These moments are not forced, they are captured. Almost anyone can line people up and make posed group photographs. It takes extra effort to seek out the emotional moments, but the reward is certainly worth it.

All three of these images were made on the Nikon 8008s 35mm camera. The quick autofocus of this camera makes it ideal for the split-second moments of emotion. I chose Kodak TMZ 3200 film for these images. With only normal room lights, the fast film and the fast lens (80–200mm f2.8 Nikon) made these images possible.

When a couple hires you to photograph their wedding, they are trusting you with one of the most important days in their lives. Months and sometimes years of dreams and planning go into the day. They are spending a lot of money on the event and investing in your photography. You only have one shot, so you should own the finest and most dependable equipment available to you. Keep it in good working order and check it throughout the day. Between each roll of film, I look through the lens to make sure the flash is firing in sync with the lens. This simple habit can save you much grief and even a lawsuit. If you check between each roll and do notice a problem, you can recreate the images taken on that last roll of film. It may be a bit of a hassle, but it's better than losing forever the happenings of the day. Of course, it goes without saying that you should have backup equipment with you at every wedding or photo assignment. You never know when a sync cord will break, or a lens will malfunction. Like the Boy Scouts always say, "Be prepared."

Every wedding has its own personality; I try to capture its unique flavor in my images.

Beginning the Journey

The pose is quite simple, a profile of the bride and ⅔ view of the groom. Both the bride and groom placed their weight on their inside foot. This dropped their shoulders next to each other, adding to the feeling of closeness and togetherness of the couple.

The background design is one of the elements that adds interest to this image. The lines of the overhang and the railing lead your eye to the couple and add to the triangular composition of the image.

One of the elements of good photography is direction of light. Here, the main light came from the open sky to the right of the groom. This placed strong directional light on both people. Directional light also gives dimension to photographs. Here, notice how it emphasizes the detail in the bride's gown.

Brides want to feel special. Anything I can do to make a bride feel like Cinderella adds to her enjoyment of her wedding. I photograph her in the most pleasing, flattering manner possible, and do everything in my power to make her feel and look beautiful.

My wife and I photograph together at the wedding. I usually photograph in color, while Barbara concentrates on black & white images. I do the portraits and group photographs and capture the details and special moments that will appear in color in the album, while Barbara works in a photojournalistic style. Her storytelling images beautifully capture the details that go into the wedding, creating a more intimate documentation of the day. Women see weddings differently and are more emotionally involved in the photography. Freeing Barbara from the obligation to get the "must-have" traditional images allows her to find those magical images that tell the rest of the story.

Barbara uses Kodak TMZ 3200 high-speed film, fast Nikon lenses and no flash, allowing her to blend in and photograph people as they are. She is in the dressing room as the bride and bridesmaids dress and prepare for the ceremony—an exciting and active part of the day that is often overlooked. Watching and listening to the bride provides Barbara with inside information about the special touches the bride has worked hard to plan for the day. This helps us direct our photography and personalize the bride's. After viewing her album, we often hear a bride exclaim something like "I can't believe you got a photograph of my mom's handkerchief—it belonged to my favorite grandmother!" Of course, we never would have known that had Barbara not been in the dressing room, paying attention to all those special details.

Anything I can do to make a bride feel like Cinderella adds to her enjoyment of her wedding.

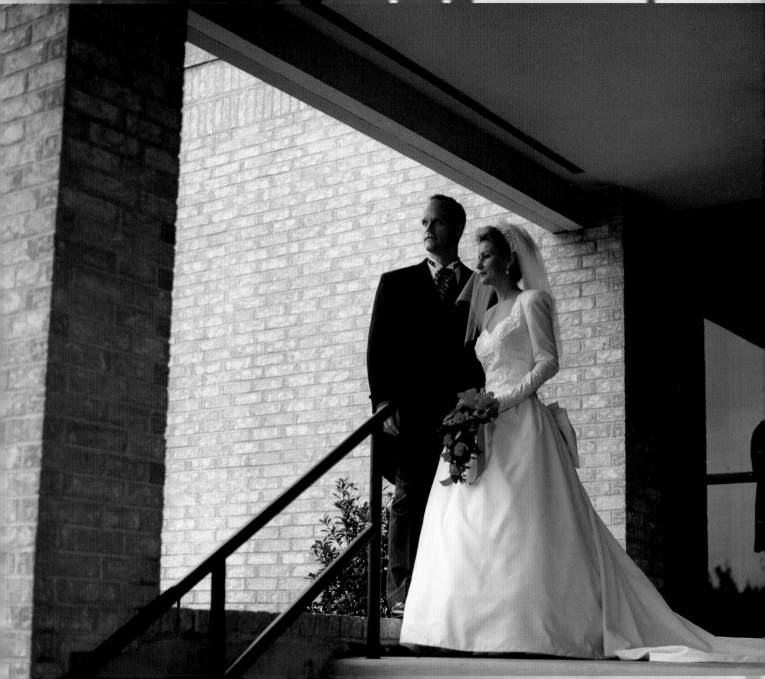

This is another example of creating wonderful portraits simply by putting people in a place that has good light (here, a porch). Place them in good positions and then let them react naturally.

When posing a bride, I take into consideration the cut of her dress as well as her shape and size. Very tall, slender brides are posed in a more flowing pose. With larger brides, or brides with very large dresses, I make some poses hiding some of the dress. This slenderizes the bride and brings your attention to her face and/or the bodice of the dress. I will sometimes bring other people or flowers up to give the illusion of a smaller dress.

Even posed photographs don't have to *look* posed. My goal is very natural-looking photographs. At some weddings, almost no posing is required. At other events, people seem more stiff and uncomfortable. My job is to make the subjects feel relaxed, or pose them so they look great.

The 250mm lens, used wide open at f5.6, made the distracting background go out of focus. Notice the bright sky in the upper part of the image. That area would have been very distracting with a smaller focal-length lens. The spots of light would have appeared sharper and more distinct.

Always look for the story *behind* the story. Some of my best images come right after I shoot the photograph I'd first planned. I will make an exposure of an event at a wedding, but instead of putting the camera down, I continue to watch for natural reactions and emotions. These candid moments show the personalities of the people and the spirit of the wedding.

When posing a bride, I take into consideration the cut of her dress and her shape and size.

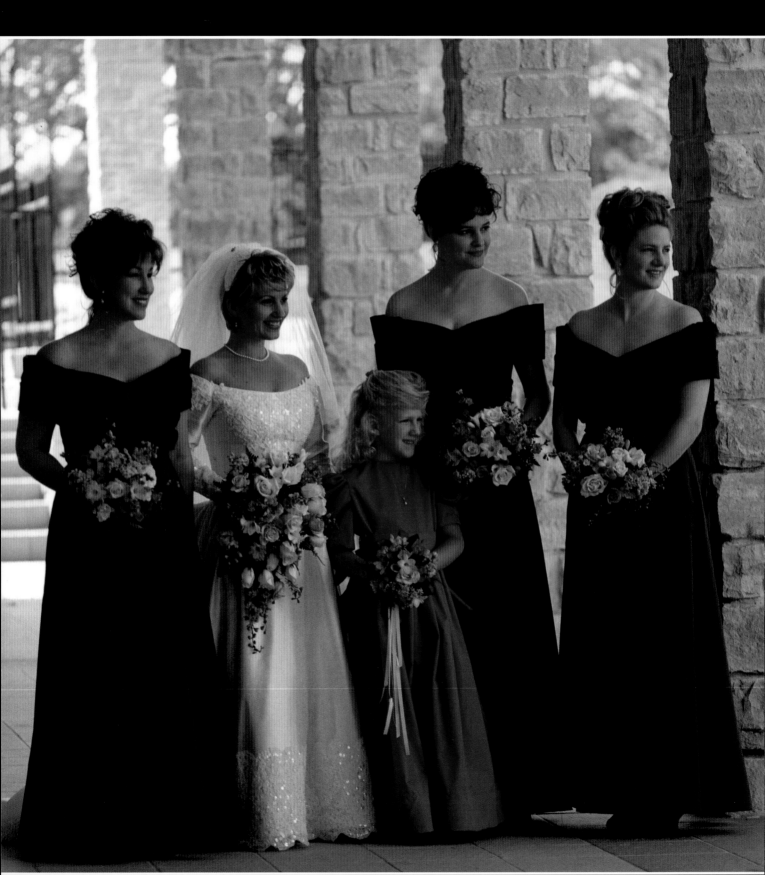

This particular image has a lot going for it: there is nice directional light and each pose seems relaxed and quite natural. Photographs like these showcase the togetherness of the group and make great post-wedding bridal party gifts; they also make great additions to wedding albums.

Years ago, we supplied our brides with proof books that they would sift through to determine which images they wanted to order for their wedding albums. Brides would sometimes have their proof books out for months, sometimes over a year, before they attempted to figure out how they would lay out their albums. Then they would come to me for help.

About fifteen years ago, we figured out that there was a better way to handle album design: we decided to do it for the brides. My wife Barbara carefully puts each of the images in storytelling order and creates the layout. She includes every great image taken at the wedding, using 4x5-inch images to panoramics—and everything in between. In four to five weeks, we deliver a complete, storytelling album to the bride.

Recently, a client told me that her sister-in-law, who had married almost a year earlier, had just received her album. To me, this is terrible. Designing the album at the studio saves a lot of time both for us and our client. We also save money in finishing costs—and can pass the savings on to our brides by providing more images at a lower price. This is one of those "everybody wins" situations. The bride wins because she can enjoy her album sooner. Everyone who sees the album wins because they get to see the photographs in a logical, storytelling format. We win because our images look better in the album than they would in a proof book. We found that more people see the bride's photographs in the first month that she has them than in the rest of the first year. With the faster production, we are able to sell more images while everyone's excitement level about the event is still high.

Our brides enjoy this service as much as they enjoy the wedding images.

Designing the album at the studio saves a lot of time both for us and our client.

We Can't Start without You

There are times when you are working very fast and the lighting conditions require that you use an on-camera flash. Use this tool competently, and your wedding images will look better. Use it poorly, and your photographs will have a very unnatural look.

There are posed photographs and unposed photographs, but this is a combination of both. I had just spent a week studying with Master Photographer Jay Stock at the Texas School of Professional Photography. I was in a very creative mood and wanted to do something different with the images of the groom and groomsmen. I had already done a traditional group shot, so I separated the guys into groups and spread them out. The vision I had was to show the way the guys begin to form small groups as old friends and family members separate into more familiar groupings. The groom felt responsible for the little guys and entertained them. When I saw the natural grouping begin to form, I separated the groups a little more to fill-in the large open field. Just as I began making the images, the ring bearer began to cry. Many people would have stopped making photographs and waited until the little man regained his composure. But not me—I love the real-life story that is played out in front of the lens.

This image was shot in the field behind the church. Look closely and you can see the cemetery that is common in country churchyards. The old oak trees provided some nice shade to keep too much of your attention from going to the nearer group of groomsmen, while the sunlight draws your attention to the foreground subjects.

I prefer to photograph outdoors during the last hour of the day, taking advantage of what I call "sweet light." However, that is not when this wedding took place. As a professional, you must do the very best you can with the situations you encounter. When you have hard light (direct sunlight), a soft focus filter is very effective. Here, it added to the tender feeling between the groom and the young man. I used a little fill flash to open up the shadow area on the groom and the two young boys. Since the subjects were illuminated by direct sunlight, the Sunny 16 rule applied (see page 78 for more information on this rule). To create a narrower depth of field (throwing the groomsmen in the background out of focus), I used an equivalent exposure of f8 at $\frac{1}{500}$ second. I added a flash set at two stops under that basic exposure (f4). This filled in the shadow area and added realism, but did not overpower the image.

As a professional, you must do the very best you can with the situations you encounter.

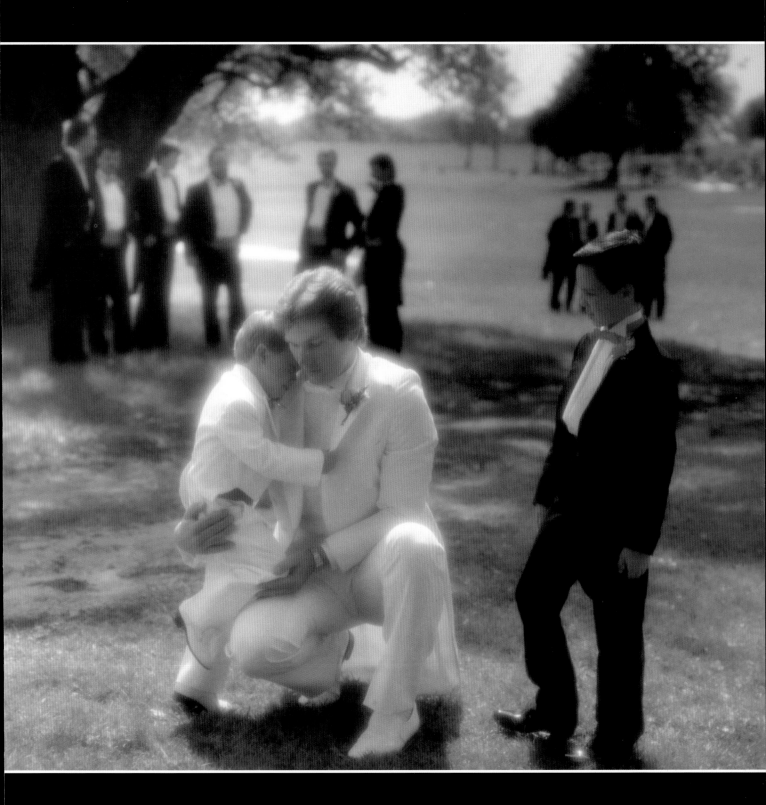

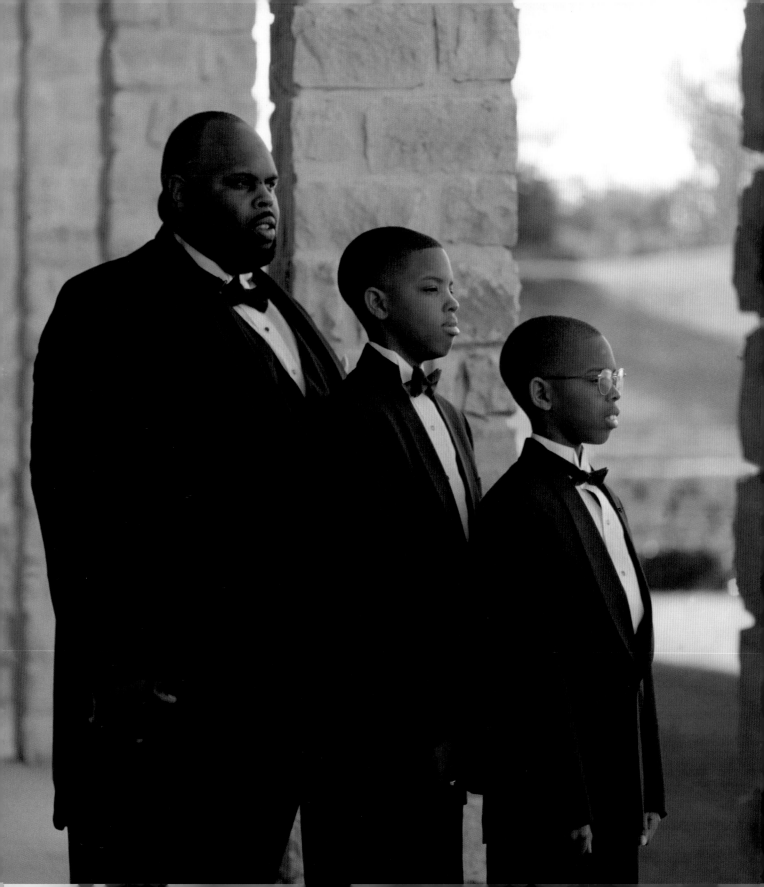

A Father and His Sons

I chose to photograph this trio of men all in the same pose. This added strength to the image. The pose also mirrors the strong columns in the background. Having all three looking in the same direction gives a sense of purpose to the image.

One of the keys to great natural light photography is the time of day that the image is made. In my opinion, the best time of day to photograph outdoors is about thirty minutes before sunset to about thirty minutes after sunset. The light is softer, has less contrast and provides the beautiful quality of light I require for my images. This image was made a little before the perfect time, so I used the large north-facing porch to provide the direction of light and to block the harder light you see in the background.

Finding the right light is one of the first steps in successful natural light photography. Find a good, clean source of light or open sky with light that is fairly broad and close to the horizon. I like to work in open shade in the late afternoon. To select the right spot, stand where the subject will stand and look toward the camera. You should see a fairly large area of open sky on one side. If that patch of open sky is directly behind the camera, the light will seem flat, creating little roundness on the subject's face. You also don't want the light to come from above, since this will create shadows under the eyes. Think of the open sky as a big window, and look for light that has strong directional qualities (like window light). Remember that a porch will work well as a light modifier as it will cause light to fall on the subject from one direction.

Look at your subject's face and examine the way the light shapes it. Strive for light that gently wraps around, illuminating each feature and lighting one side of the face while just touching the other.

Finding the right light is one of the first steps in successful natural light photography.

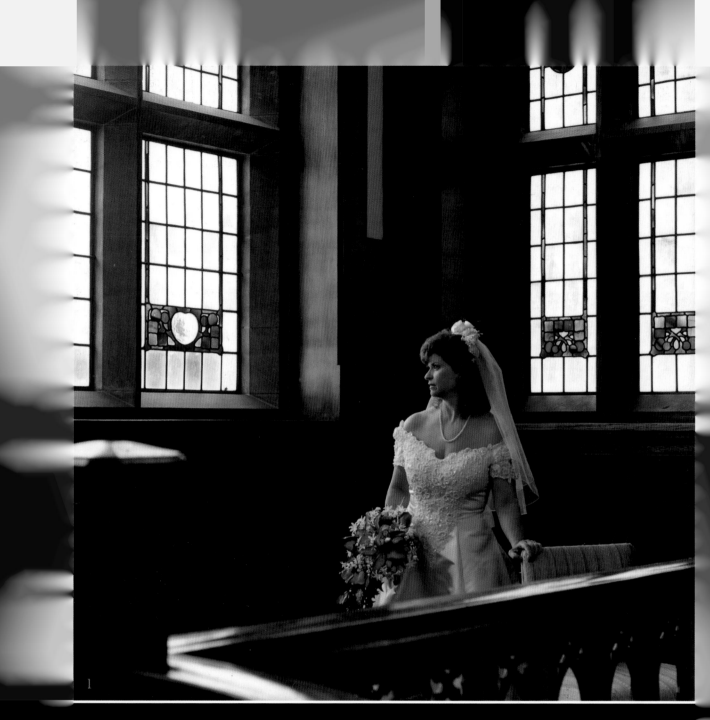

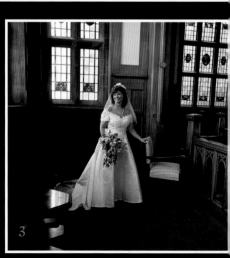

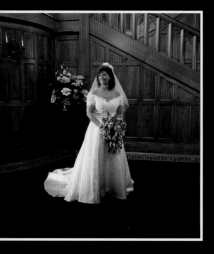

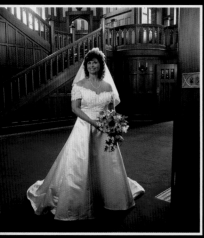

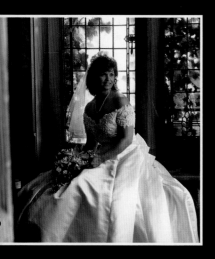

Series in a Small Space

The images shown here were made in a small space. As you can see, small changes in the pose, camera position and composition can add a lot of variety to any series.

There was more window light filtering in at the location where image 1 was taken than was present in image 2. Image 1 is less contrasty than image 2, since there is more light in the room.

In image 2, I placed the bride in a position where there would be nice light on her face. There was no flash or reflector used to create this image. I simply took a meter reading of the window, then made the image. If you want a dramatic shot, this is one way to get one.

Image 3 shows great lighting on the bride's face. When you have great lighting on the face, you can move your camera around or capture your image as a full-length shot, three-quarter image or profile portrait, while still maintaining the high-quality lighting. With this great lighting, I didn't need any flash, reflectors, or anything else.

In image 4, you see a lot of woodwork. I moved the bride back and used a lot of available light, which was coming in from her right; it provided beautiful illumination with nice direction. Again, I used only available light.

There was no available light falling on the bride's face when I captured image 5. To remedy the situation, I brought a light off to the side on a little softbox. I positioned it at about 45 degrees from the subject's face, then metered the flash to obtain a reading of f5.6. I then set the camera to f5.6. I needed to fill-in the shadow side of her face and to really pick up the room ambience, so we did a one-second exposure. This filled the room with light and created the proper exposure. Again, there was no camera shake because I used a tripod.

In image 6, the window decorated with vines was used as a background; we used the other, larger window as a main light. Again, there were no reflectors and no flash used—we just metered the bride's face and set the camera as the reading dictated. We positioned the bride so that her body was turned away from the light, which skimmed across the gown. We turned her face back into the light, achieving a nice S-shaped pose and beautiful light on her face.

Look for places where there is nice light coming in, and you'll be rewarded with beautiful images.

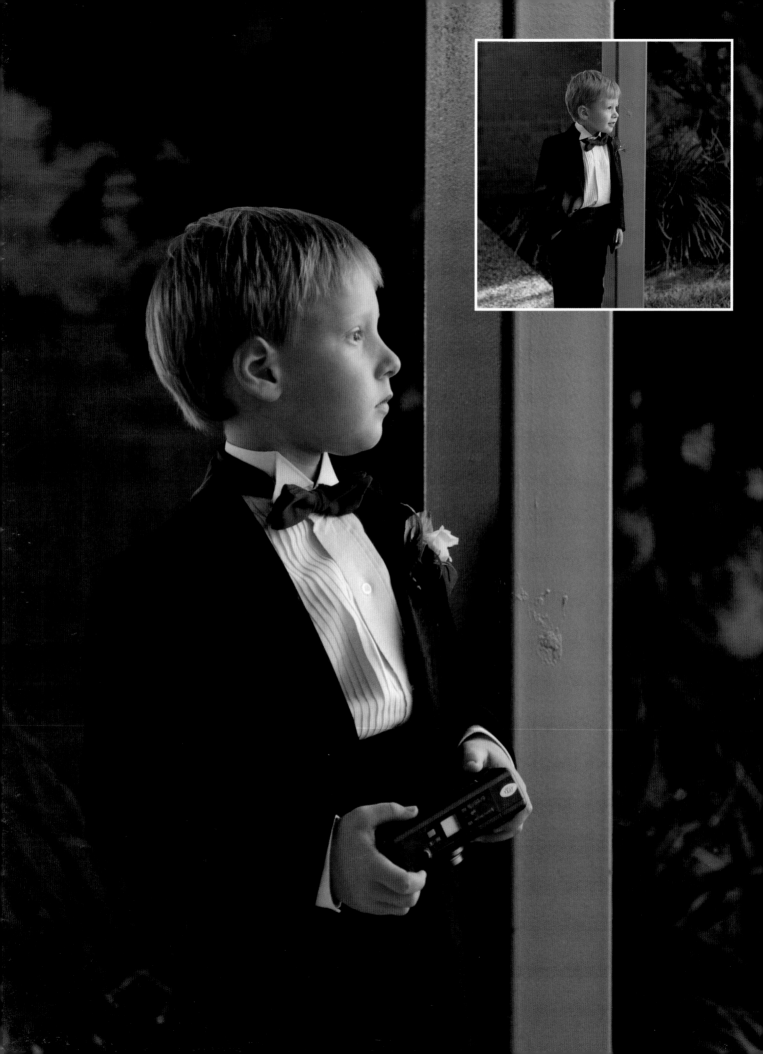

I enjoy photographing children at weddings. They are spontaneous, innocent and full of joy, and add personality to the wedding album. These young men played important roles in the wedding—both were ring bearers; the older boy was also "assistant photographer."

Here, the older boy was was positioned with his weight on his back foot to drop the shoulder and create a nice flow in the image. His head was tilted slightly toward his lower shoulder, and we have a profile view of the face. The younger boy is leaning into the post, with his weight on his back foot, and his front leg crossed over it. This pose is a modified profile, and while it is not perfect, it is just fine in my opinion.

Photographers have a great deal of control in attracting the segment of their market that they are most interested in photographing. If you want to attract upscale clients, your promotional materials must be upscale. We have developed an eight-page informational brochure that we send to prospective brides. It includes our philosophy on wedding photography, our accomplishments in the industry, prices, policies and, most importantly, a dozen or more images. Some are printed onto the brochure itself, but in every one we also include actual images from other weddings we have photographed.

My first contact with each bride typically occurs on the telephone. I use a phone script to keep me on track during our conversation, and take notes on her wants, needs and desires. Armed with this information, I create a custom package for her. I include images that reflect the style of photography she likes, along with photographs taken at her church or reception area when possible. If children will be included in the ceremony, I enclose several images showing how we photograph children at weddings. If she has mentioned that she enjoys romantic images, I include some of those. I also include examples that illustrate my natural style of photographing weddings.

Personality is one of the most important factors in becoming a successful wedding photographer. A bride needs to have a good feeling about what you will be like at her wedding, and how you will treat her and her guests on her special day. How do you let her know she'll enjoy working with you more than another photographer? I let my past clients tell her. I display an album that includes the nice cards and letters past clients have written to me. On one page is the card or letter, and on the other is a photograph from the wedding. Happy past clients are my best salespeople.

A bride needs to have a good feeling about what you will be like at her wedding.

Kodak Moments

This is a fun time at the wedding and a great opportunity for you to capture great "Kodak moments"—those that show what truly happened that day. There really is no posing going on for exit shots, but you do have to position yourself in the proper place to capture the best images.

You do have to position yourself in the proper place to capture the best images.

Again, the on-camera flash saves the day. No elaborate setups were used to create these images; they are the result of being prepared at just the right moment. I created the photograph on the opposite page by taking the image from a low angle as the couple ran the gauntlet of family and friends. The exposure was $\frac{1}{500}$ at f8; the flash was set at f8.

In the photograph below, I used the same technique but with a slow shutter speed ($\frac{1}{15}$) to accent the motion. I panned the camera during the exposure. I really enjoy the spontaneous feel of the image.

Shot List

The list below outlines some of the images I do at weddings. These images are certainly not all of the subjects or groupings that I shoot, and I may not do all of these images at every wedding.

Be creative, and look for the unique things happening at each wedding. This is just a "tickler" list. When you get stuck and can't think of photographs to take, go over this list and see if any of these images fit what is happening at your wedding.

Before the Wedding

The altar
The church (outside)
Groom alone (close-up and full length)
Groom and groomsmen
Groom with his immediate family
Groom with brothers and sisters
Groom with parents
Groom with mother
Groom with father
Groom's parents alone
Groom with grandparents
Grandparents alone
Bride alone (close-up and full length)
Bride's bouquet/bridesmaids' flowers
Bride with bridesmaids
Putting on garter, penny in shoe, etc.
Bride with each bridesmaid
Bride with her immediate family
Bride with brothers and sisters
Bride with parents
Bride with mother
Bride with father
Bride's parents alone
Bride with grandparents
Grandparents alone
Guest book attendants

The Wedding

Mothers being seated
Bride with father/escort walking down aisle
Wedding ceremony (natural light)
Bride and groom coming down aisle
Hugging shots after wedding
Throwing rice

Return to Altar

Re-create the exchange of rings
Re-create the kiss
Bride and groom with wedding party
Bride and groom with pastor
Bride and groom with best man and maid of honor
Bride and groom with bride's parents
Bride and groom with bride's immediate family
Bride and groom with bride's extended family
Bride and groom with bridesmaids (if not done before)
Bide and groom with groomsmen (if not done before)
Bride alone at altar (back of dress)
Bride and groom alone at altar (from the back)
Bride alone at altar (front)
Bride and groom alone at altar (front)
Groom alone
Bride and groom in aisle
Bride and groom leaving church
Bride and groom getting into limo
Bride and groom in back seat of limo

Reception

Flowers/details around reception hall
Wedding cakes
Candids of guests
Toast as it happens
Bride and groom's first dance
Bride's/groom's dance with parents
Everyone dancing
Bride and groom with toasting glasses
Bride and groom toasting
Bride and groom cutting cake
Bride and groom feeding cake
Bride throwing bouquet
Groom taking off garter
Groom throwing garter
Bride and groom with catchers
Hand shot with ring

Cameras

Hasselblad 500 CM, 503CW
major lenses 50mm, 120mm, 150mm, 250mm
10 Madison Rd
Fairfield, NJ 07004
(201)227-7320
www.hasselblad.se

Nikon
1300 Walt Whitman Rd.
Melville, NY 11747
www.nikon.com

Film

Eastman Kodak
Portra Films
Promise of Excellence portrait guarantee program
(800)717-4040
www.kodak.com

Lens Shade, Soft Focus Filters

Lindahl Specialities
800 W. Beardsley Ave
Elkhart, IN 46514
(219)296-7823

Lighting Equipment

Quantum
1075 Stewart Ave.
Garden City, NY 11530
(516)222-6000
www.qtm.com

Meter

Sekonic L508 Zoom Master
Westchester Plaza
Elmsford, NY 10523
(914)347-3300

Modular Belt and Case System

Kinesis Photo Gear
5875 Simms St.
Arvada, CO 80004
(303)425-1314
www.kinesisgear.com

Photo Education

Photo Vision—A Video Magazine
15513 Summer Grove Court
North Potomac, MD 20878
www.photovisionvideo.com

Professional Organizations

Professional Photographers of America (PPA)
57 Forsyth St. N.W., #1600
Atlanta, GA 30303
(800)786-6277/(404)522-8600
Fax: (404)614-6400
www.ppa-world.org

Wedding & Portrait Photographers International (WPPI)

1312 Lincoln Blvd.
PO Box 2003
Santa Monica, CA 90406
(310)451-0900
www.wppi-online.com

Props

American Photographic Resources
Randy & Patti Dunham
PO Box 820127
Ft. Worth, TX 76182
(817)431-0434

Tripod

Bogen 3050, 3033
565 E Crescent Ave
Ramsey, NJ 07446
(201)818-9500
www.manfrotto.it:80/bogen/

Wedding Albums

Art Leather
(888)AL ALBUMS
www.artleather.com

Albums Inc.
(972)247-0677
www.albumsinc.com

For up-to-date information on Doug Box's speaking/workshop schedule, contact him via e-mail at <dougbox@aol.com>, or visit his web site: www.dougbox.com and www.simplyselling.com.

Our Philosophy

We create artistic portraits and wedding albums that tell the personal story behind each of the weddings we photograph. The images have a scenic quality, are emotionally charged, and have a natural look. We document the day with a combination of traditional, photojournalistic and spontaneous images.

Our experience and professionalism ensure the bride and groom won't be dragged away from their guests every few minutes. It's their day; they want to feel special. We help them do that!

Doug and Barbara Box

Index

Other Books from
Amherst Media

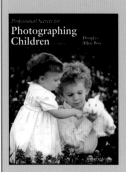
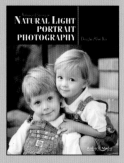
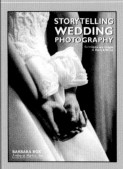

Photo Retouching with Adobe® Photoshop®
2nd Edition
Gwen Lute

Designed for photographers, this manual teaches every phase of the process, from scanning to final output. Learn to restore damaged photos, correct imperfections, create realistic composite images and correct for dazzling color. $29.95 list, 8½x11, 120p, 60+ photos, order no. 1660.

Marketing and Selling Black & White Portrait Photography
Helen T. Boursier

A complete manual for adding b&w portraits to the products you offer clients (or offering exclusively b&w photography). Learn how to attract clients and deliver the portraits that will keep them coming back. $29.95 list, 8½x11, 128p, 50+ photos, order no. 1677.

Innovative Techniques for Wedding Photography
David Neil Arndt

Spice up your wedding photography (and attract new clients) with dozens of creative techniques from top-notch professional wedding photographers! $29.95 list, 8½x11, 120p, 60 photos, order no. 1684.

Infrared Wedding Photography
Patrick Rice, Barbara Rice & Travis Hill

Step-by-step techniques for adding the dreamy look of black & white infrared to your wedding portraiture. Capture the fantasy of the wedding with unique ethereal portraits your clients will love! $29.95 list, 8½x11, 128p, 60 images, order no. 1681.

Photographing Children in Black & White
Helen T. Boursier

Learn the techniques professionals use to capture classic portraits of children (of all ages) in black & white. Discover posing, shooting, lighting and marketing techniques for black & white portraiture in the studio or on location. $29.95 list, 8½x11, 128p, 100 photos, order no. 1676.

Portrait Photographer's Handbook
Bill Hurter

Bill Hurter has compiled a step-by-step guide to portraiture that easily leads the reader through all phases of portrait photography. This book will be an asset to experienced photographers and beginners alike. $29.95 list, 8½x11, 128p, full color, 60 photos, order no. 1708.

Professional Marketing & Selling Techniques for Wedding Photographers
Jeff Hawkins and Kathleen Hawkins

Learn the business of successful wedding photography. Includes consultations, direct mail, print advertising, internet marketing and much more. $29.95 list, 8½x11, 128p, 80 photos, order no. 1712.

Traditional Photographic Effects with Adobe® Photoshop®
Michelle Perkins and Paul Grant

Use Photoshop to enhance your photos with handcoloring, vignettes, soft focus and much more. Every technique contains step-by-step instructions for easy learning. $29.95 list, 8½x11, 128p, 150 photos, order no. 1721.

Master Posing Guide for Portrait Photographers
J. D. Wacker

Learn the techniques you need to pose single portrait subjects, couples and groups for studio or location portraits. Includes techniques for photographing weddings, teams, children, special events and much more. $29.95 list, 8½x11, 128p, 80 photos, order no. 1722.

Beginner's Guide to Adobe® Photoshop®
Michelle Perkins

Learn the skills you need to effectively make your images look their best, create original artwork or add unique effects to almost any image. All topics are presented in short, easy-to-digest sections that will boost confidence and ensure outstanding images. $29.95 list, 8½x11, 128p, 150 full-color photos, order no. 1732.

Professional Techniques for Digital Wedding Photography
Jeff Hawkins and Kathleen Hawkins

From selecting the right equipment to building an efficient digital workflow, this book teaches how to best make digital tools and marketing techniques work for you. $29.95 list, 8½x11, 128p, 80 full-color photos, order no. 1735.

Photographer's Lighting Handbook

Lou Jacobs Jr.

Think you need a room full of expensive lighting equipment to get great shots? Think again. This book explains how light affects every subject you shoot and how, with simple techniques, you can produce the images you desire. $29.95 list, 8½x11, 128p, 130 full-color photos, order no. 1737.

Professional Digital Photography

Dave Montizambert

From monitor calibration, to color balancing to creating advanced artistic effects, this book provides photog-raphers skilled in basic digital imaging with the techniques they need to take their photography to the next level. $29.95 list, 8½x11, 128p, 120 full-color photos, order no. 1739.

Group Portrait Photographer's Handbook

Bill Hurter

With images by over twenty of the industry's top portrait photographers, this indispensible book offers timeless tips for composing, lighting and posing dynamic group portraits. $29.95 list, 8½x11, 128p, 120 full-color photos, order no. 1740.

Lighting and Exposure Techniques for Outdoor and Location Portrait Photography

J.J.Allen

This book teaches photographers to counter-balance the challenges of changing light and complex settings with techniques that help you achieve great images every time. $29.95 list, 8½x11, 128p, 150 full-color photos, order no. 1741.

Toning Techniques for Photographic Prints

Richard Newman

Whether you want to age an image, provide a shock of color, or lend archival stability to your black & white prints, the step-by-step instructions in this book will help you realize your creative vision. $29.95 list, 8½x11, 128p, 150 full-color/b&w photos, order no. 1742.

The Best of Wedding Photography

Bill Hurter

Learn how the top wedding photographers in the industry transform special moments into lasting romantic treasures with the posing, lighting, album design and customer service pointers found in this book. $29.95 list, 8½x11, 128p, 150 full-color photos, order no. 1747.

Success in Portrait Photography

Jeff Smith

No photographer goes into business expecting to fail, but many realize too late that camera skills alone do not ensure success. This book will teach photographers how to run savvy marketing cam-paigns, attract clients and provide top-notch customer service. $29.95 list, 8½x11, 128p, 100 full-color photos, order no. 1748.

Professional Digital Portrait Photography

Jeff Smith

Digital portrait photography offers a number of advantages. Yet, because the learning curve is so steep, making the tradition to digital can be frustrating. Smith shows readers how to shoot, edit and retouch their images—while avoiding common pitfalls. $29.95 list, 8½x11, 128p, 100 full-color photos, order no. 1750.

The Best of Children's Portrait Photography

Bill Hurter

See how award-winning photographers capture the magic of childhood. *Rangefinder* editor Bill Hurter draws upon the work of top professional photographers, uncovering the creative and technical skills they use to create their magical portraits. $29.95 list, 8½x11, 128p, 150 full-color photos, order no. 1752.